# WILDLIFE PHOTOGRAPHY AT HOME

An Hachette UK Company
www.hachette.co.uk

First published in the UK
in 2019 by Ilex, an imprint of
Octopus Publishing Group Ltd
Carmelite House
50 Victoria Embankment
London EC4Y 0DZ
www.octopusbooks.co.uk
www.octopusbooksusa.com

Distributed in the US by Hachette Book Group
1290 Avenue of the Americas, 4th & 5th Floors,
New York, NY 10104

Distributed in Canada by Canadian Manda Group
664 Annette Street, Toronto, Ontario, Canada M6S 2C8

Design and layout copyright
© Octopus Publishing Group 2019
Text and illustrations copyright
© Richard Peters 2019

Publisher: Alison Starling
Commissioner: Frank Gallaugher
Consultant Publisher: Adam Juniper
Managing Editor: Rachel Silverlight
Art Director: Ben Gardiner
Designer: Geoff Borin
Senior Production Manager: Peter Hunt

ISBN 978-1-78157-676-2

A CIP catalogue record for this book
is available from the British Library.

Printed and bound in China

10 9 8 7 6 5 4 3 2 1

JULY 2019

# WILDLIFE PHOTOGRAPHY AT HOME

## TAKE GREAT PHOTOS IN YOUR OWN BACKYARD

**ilex**

EUROPEAN WILDLIFE PHOTOGRAPHER OF THE YEAR

# RICHARD PETERS

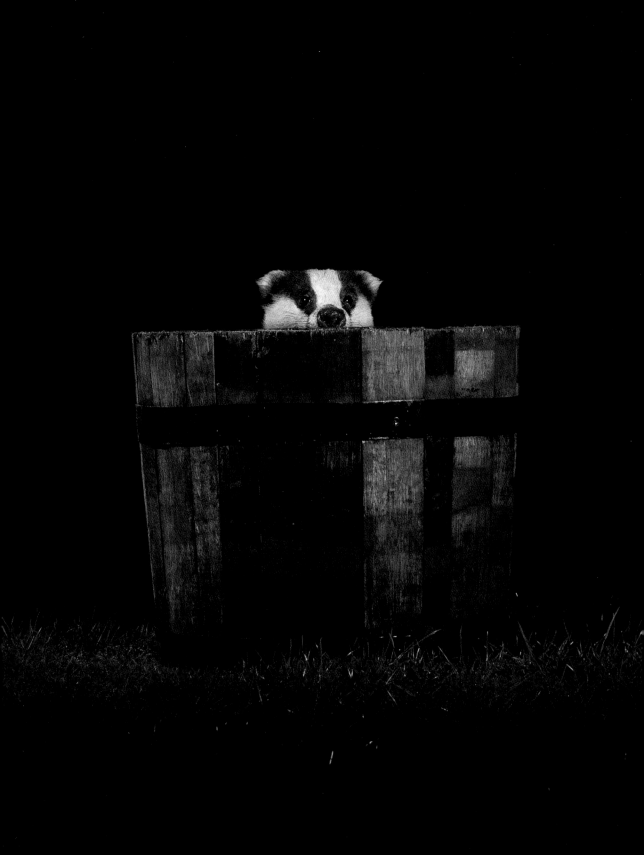

# CONTENTS

# INTRODUCTION

**There is something intensely satisfying about being in the presence of wildlife. I often think of my camera viewfinder as a private window into another world, a world that is entirely overlooked by many people as they rush around without pause for thought or taking time to sit back and absorb the nature around them.**

Peering in through this private window is addictive, and I enjoy travelling to get my fix. From the frozen valleys of Yellowstone National Park to the sun-scorched plains of the Maasai Mara, there's no doubt that spending time in such destinations is both exhilarating and inspiring. However, there is somewhere else that can be just as inspirational as these far-flung exotic locations. And this somewhere is very accessible and free to visit. I am, of course, talking about our very own gardens and backyards.

With the human population increasing and cities encroaching on the countryside more and more, urban areas have developed wildlife populations of their own and people have become incredibly welcoming towards them. We encourage wildlife into our yards by offering supplementary sources of food, providing fresh water and nest boxes, and generally creating inviting environments that animals will thrive in.

Your yard might not seem like the most inspiring of locations at first glance, especially if you are looking out the window at a desolate space in the dead of winter. I guarantee you, though, there will be something out there to photograph.

My yard, for example, isn't particularly large, it's a little rough around the edges and seems to get very few of the usual garden birds one might expect. However, in time, I discovered it wasn't the wildlife wasteland it first appeared to be, and I'm willing to bet the same can be said for yours too. Sometimes it just takes a fresh perspective to provide motivation.

With that in mind, I wrote this book to inspire you to spend more time thinking creatively at home, to see what can be achieved in your own private nature reserve.

The following pages assume some knowledge of the basic relationship between shutter speed, aperture and ISO, but whether you are a beginner or a more advanced photographer, there is something for everyone. All images presented were taken at my home, and I hope that they will inspire you to go wild with your own camera in your own backyard.

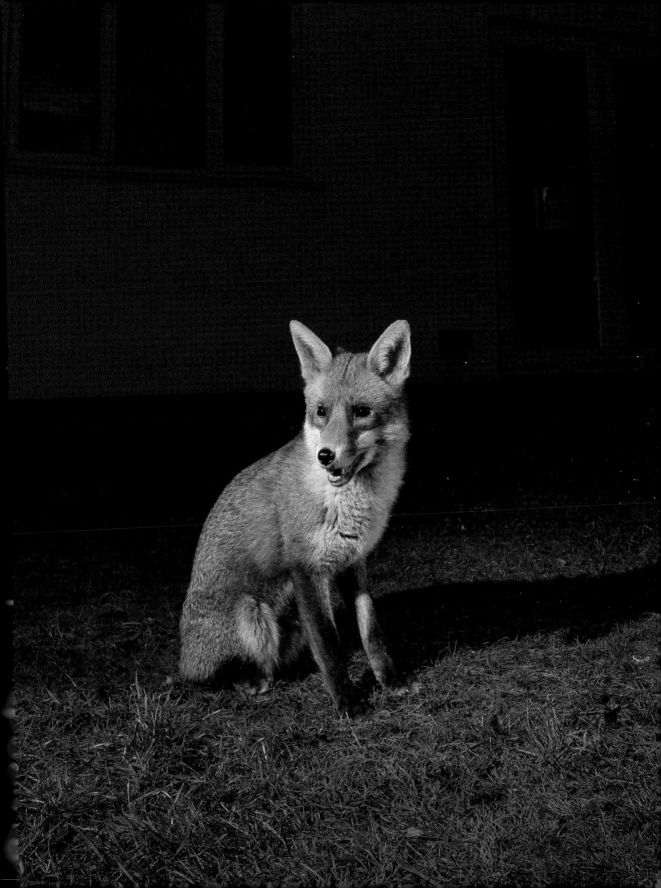

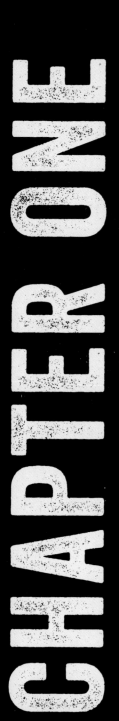

# CHAPTER ONE

# BASIC PRINCIPLES

**Master the fundamentals and everything else will fall into place**

# THE IMPORTANCE OF PERSEVERANC

**Before delving into any wildlife photography, be it a long-term project or just a few hours here and there, the single most important piece of advice that can be given, regardless of subject or location, is that perseverance is key.**

Wildlife photography rarely grants instant success and gratification. Of course, there is instant gratification in that you can see your images on the back of the DSLR just as soon as you press the shutter. Here, however, we are talking more about the gratification of capturing a special image that stands head and shoulders above the rest. Such photos can, at times, feel out of reach, especially as it's all too easy to look online at other photographer's websites, Facebook pages and Instagram feeds, and when not a bad photo is to be seen, conclude that those photographers take only these special successful frames. It's as if every image in their collection is an exercise in technical perfection, masterful composition and an amazing ability to seemingly always be in the right place at the right time. The truth is anything but this simple. What you are seeing are only the very best images they have taken, the images they want you to see. They aren't showing you the thousands of badly framed, poorly lit, soft and mistimed photos. They have them, make no mistake, because we all do. Instead, what you are seeing is a culmination of time, effort and hard work. What you are seeing is the result of their perseverance.

The rules don't change when you are working close to home. It's important to understand that just because you have quick access to a location, it doesn't mean you don't have to work hard and put the effort in. What it does mean, however, is that putting that effort in is made somewhat easier with no time restrictions or financial burdens to potentially restrain you, as with other photographic endeavours.

As a very basic example, if you're trying to photograph small, quick birds in flight around a feeder, you may start by working with large apertures such as $f/4$, to allow in as much light as possible to keep your shutter speeds up. This requires working with a small depth of field, and capturing those fast little birds in the right pose with their heads in focus won't be easy; it could take you thousands of frames to capture just one or two that are good. During that process, you will find yourself fine-tuning your approach, your settings and how and where to prefocus to achieve the perfect shot. You then have that knowledge to use in future, should you want take a similar photo again. The hard work you put in initially will enable you to repeat the process with a much higher keeper rate in the future. On an even more basic level, you may find yourself wanting an image of your subject in the right place, and in the right type of light. Through months of observation, you may learn that that window is open for only a few weeks at a specific time of year. That's the payoff of perseverance, and it's what makes all of us better photographers. It's a constant learning process, and

it is thanks to going through the motions over and over that we are able to react quickly and make the most of any situation we might find ourselves in.

For me, especially in the early days, there have been times where I've been hugely frustrated trying to capture specific photos. In total, it took me three months to secure a single decent daylight portrait of the foxes visiting my garden (see pages 52–59), and it's an opportunity that I didn't get again after the first successful frame.

When the foxes stopped coming in daylight, I then had to learn an entirely new technique to photograph them. At the time, I had no idea about flash photography. There was a vast amount of trial and error, and I purchased much equipment that didn't give the results desired. When I was just starting to understand the basics of flash, I also began to experiment with camera trapping (see from page 112), and a whole new set of lessons and complications needed to be learned and overcome.

Animals are unpredictable at the best of times. Over winter, when the yard went quiet for long periods, night after night, I would try to capture only specific

▲ 1/200, *f*/5.6, IOS 200, SB-28 (x2), PIR sensor.
A badger walking across the decking is made to look as though it's walking a thin line of light through the dark by controlling what is lit. Try your own experiments with light.

preconceived frames. Some shots have taken weeks to find their way into my image library. For others, it has taken months.

My hope is to communicate to you the reality that, although it may seem like you're the only one who can't get the shot you so badly want, you're not. If you find yourself close to perfecting that image you have been desperate to capture, but the process feels like nothing more than the repetition of failure, the worst thing to do at this stage is simply give up.

Never forget the importance of perseverance. Don't rush yourself, keep learning from your mistakes, push through the frustration, and in time, your portfolio will reap the rewards.

# VISUAL APPEAL

One of the key elements to producing an aesthetically pleasing wildlife photo is strong composition that complements the subject, balances the image and gives the viewer a clear point of interest. It makes no difference whether your subject fills the frame, is a tiny aspect of it, or is bathed in the most beautiful golden light; if the aesthetics are not there, the viewer won't connect and the image becomes unmemorable. As you read through the following chapters, you'll see how the featured photographs all fall in line one way or another with the basic theories explained in this section.

The visual appeal of an image, however, goes beyond just these basics, and will be discussed later in the book (see page 124).

## THE RULE OF THIRDS

You may already have heard the idea of the rule of thirds. It's really quite simple: Imagine your image split into nine equal sections. When you place important elements at the intersections of those lines or along those lines, photos appear more balanced and visually pleasing.

## NEGATIVE SPACE

This refers to the empty areas in the image, but that's not to necessarily say they don't contain anything at all, as often they will. It is more that they do not contain key points of interest.

You can, however, use this space to place lesser elements that counter-balance the main subject.

In the most traditional scenario, the function of negative space is to provide an area within the frame that the subject could move into. This frequently works hand in hand with the rule of thirds, because placing the subject in accordance with the rule of thirds often results in negative space elsewhere in the image.

Providing space for the subject also helps the image to feel larger than it is, giving the illusion of life beyond the confines of the frame. A good tip to help with this is ensuring you do not use the centre focus point all the time, because that leads to a tendency to place your subject in the middle of the frame. Use the peripheral focus points from time to time.

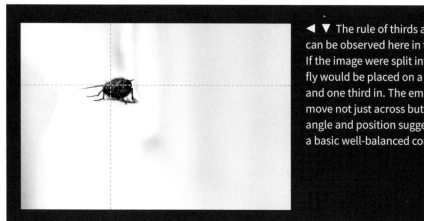

◀ ▼ The rule of thirds and use of negative space can be observed here in their most simple forms. If the image were split into nine equal sections, the fly would be placed on a junction one third down and one third in. The empty space gives it room to move not just across but also down the frame, as its angle and position suggest it might do. This creates a basic well-balanced composition.

## EYE-LEVEL PERSPECTIVES

The third compositional lesson involves trying to get eye level with your subject, which often creates a stronger image and gives a more flattering perspective. Remember that whatever the angle, in almost all cases, achieving sharp eyes is critical for viewer connection. On this page, we show the same subject photographed from the same distance, at three heights, using an aperture of ƒ/5.

▼ ▶ The image on the left, below, is taken from a standing position and suffers from having both a distracting foreground and background. The second, below right, is taken from a kneeling position and, although better, still isn't quite there. The third image, right, is taken from a position of lying on the ground, and the difference between it and the first is dramatic. In spite of being the same distance away with the same camera settings, your attention is now fixed on the wooden owl due to an intimate eye-level perspective and beautiful out-of-focus areas in the background.

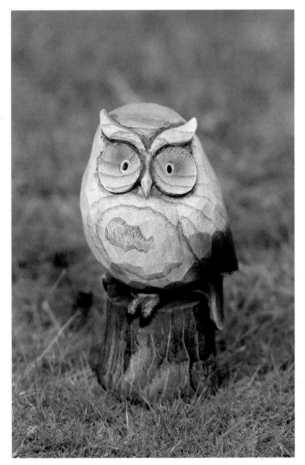 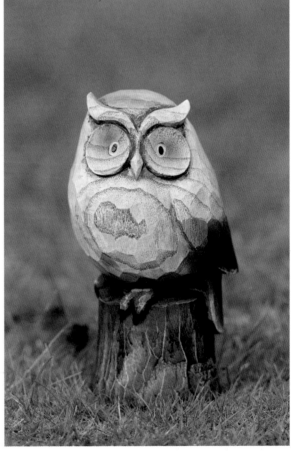

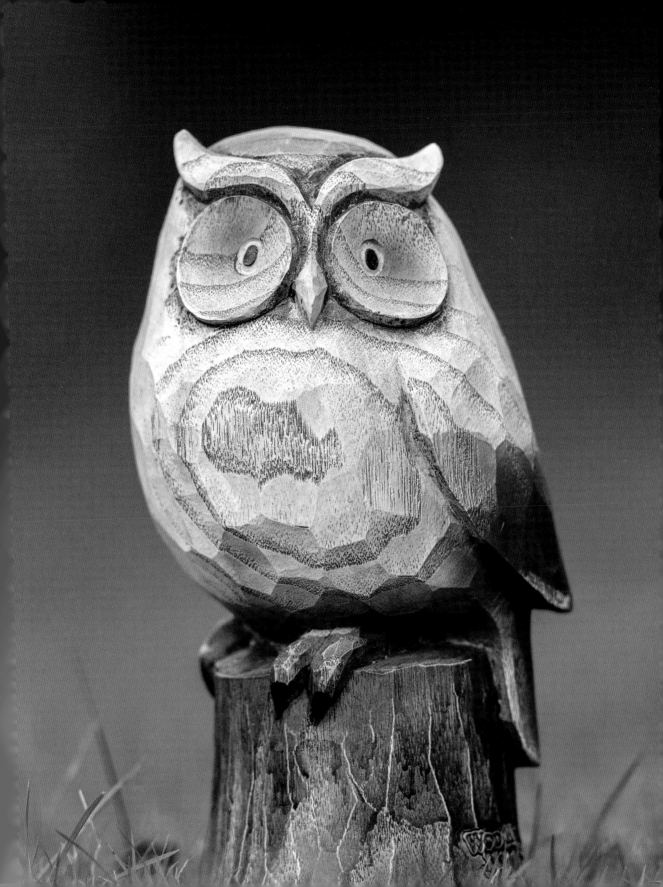

# FILLING THE FRAME

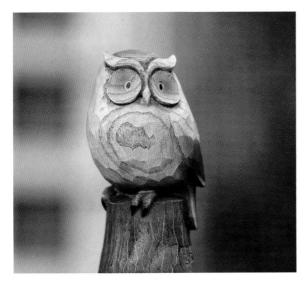

While it's always tempting to present the subject as large as possible, at times it is worth leaving some room around the frame. With a traditional portrait, there is a fine line between that space being just right and too much. If the subject dominates too much, it can make the frame feel cramped. If you leave some breathing room, however, you have the option of cropping a little tighter later if that works better.

Another incentive to leave some room and not overfill the frame is that it makes your photos commercially more appealing. If you sell, or plan to sell, your images, leaving some space gives the option for a client to add text or logos alongside the subject.

▲ **400mm, ƒ/2.8.** Even with large apertures, try to avoid shooting towards multiple contrasting background colours and unnatural shapes. These create messy distractions that lead the viewer's eye away from the main focus point of your image. Here, the subject is looking to its right, so it would have benefited from being placed farther left in the frame to improve the composition.

▼ **400mm, ƒ/2.8.** This frame is better balanced, but despite the large aperture, and even from over 30 feet away, a brightly coloured object pulls attention away from the main focus of the frame. Learning to look beyond the subject when composing your wildlife images is a key ingredient to improving the visual appeal of your work.

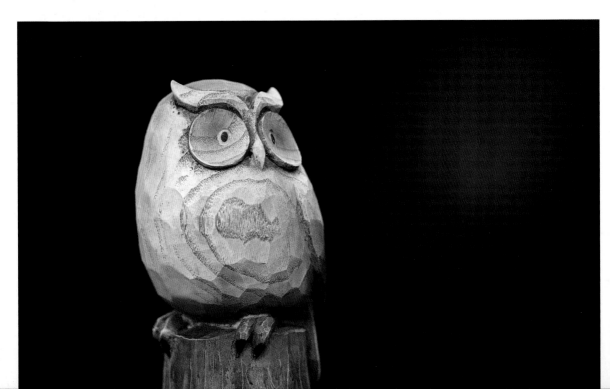

## BACKGROUNDS & DISTRACTIONS

When opting for a simple portrait, in addition to getting the light and composition right, the background is critical in making the image work. A beautiful, clean background will help the subject to pop from the frame, so it's important to keep an eye on everything you can see in the viewfinder. It's all too easy to be totally absorbed by the close-up view of your subject that a telephoto lens offers; and that small viewfinder you'll be looking through makes it easy to overlook distracting, out-of-focus objects that will stand out like a sore thumb when viewed larger on your computer screen.

There is nothing more frustrating than a portrait in which your subject is captured beautifully, but your eye is instead drawn to something behind that breaks

▲ Virtually all cameras have the ability to turn on grid lines in the viewfinder. Doing this not only helps you keep any lines straight, but also assists with composing and balancing elements within the frame.

an otherwise clean background. Yards are potentially littered with such distractions and you'd be surprised how a contrasting colour will stand out, no matter how far away it is. Holes in the hedge that allow brighter areas of light to come through, the dark trunk of a distant tree or even a pair of socks hanging on the washing line can spoil an otherwise perfect shot. Sometimes just moving a fraction to the left, right, up or down is all it takes to remove these distractions and clean up those backgrounds, shifting the viewer's attention back to the subject.

# NEXT STEPS

**The next step is to start looking at how to expand the visual appeal of your images with different focal lengths, storytelling and, as we'll discuss in the next section, the effective use of light.**

## THE WIDE-ANGLE EFFECT

When shooting with wide-angle lenses, there is less concern for fast lenses with large apertures. Unlike when shooting with telephotos, you'll often want to use a smaller aperture, giving a large depth of field, to capture as much detail in the scene as possible. Depending on the style of image you want to create and the story you want to tell with that image, a distinct advantage of using a wide angle is the result gives a greater sense of your subject's habitat.

The pictures opposite and on the following page demonstrate the same subject photographed differently to tell a story. Early one summer, I cleaned out my shed and started using it to store peanuts, bird seed, etc. Naturally, a few scraps eventually found their way onto the floor. Soon enough, one afternoon when I went out to top up the bird feeder, a jay suddenly flew out of the open shed door and up to the nearby trees. It seemed that, during his visits to the bird feeder, he had spotted the loose peanuts dotted around the shed floor and was now taking the opportunity to go inside looking for them.

This gave me an idea. I put my camera in the shed with two flashguns. I turned one backwards, facing the

dirty old white-painted plywood walls, to bounce soft light around the entire shed, and I pointed the second light at the entrance to illuminate the jay. I then placed a PIR sensor (a 'passive infrared', or motion, sensor) pointing at the doorway, so that when the jay flew in, it would trip the camera and a photo would be taken.

It didn't take long before the winged raider returned and my plan fell into place. The result, and in comparison a more traditional image, can be seen overleaf and right, respectively.

The wide-angle image on page 20 is completely different to the telephoto portrait shown at right. The former tells the story of this cheeky opportunist, and this, to me, makes it the far more interesting and visually appealing image of the two.

Besides using a wide field of view, we're at the subject's eye level, and the rule of thirds has been applied, placing the jay bottom-left with the shed window top-right to counterbalance the image.

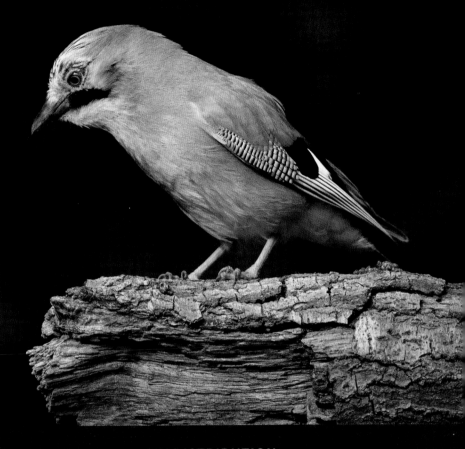

▲ **600mm, 1/500, ƒ/4, ISO 100, TriggerTrap.** By sitting in the kitchen and using a long shutter release cable, I was able to capture a pleasant but generic image of the notoriously wary jay. This is your typical telephoto image and, while it serves as a good record shot of the species, it isn't memorable or different to countless others out there.

## JAY DISTRIBUTION

The Eurasian Jay seen in these photographs belongs to the crow family, and you are more likely to hear their call than to see them since they are shy woodland birds. They are found across continental Europe and eat acorns, nuts, seeds and insects. The distinctive American Blue Jay, widespread across the US, also belongs to the crow family.

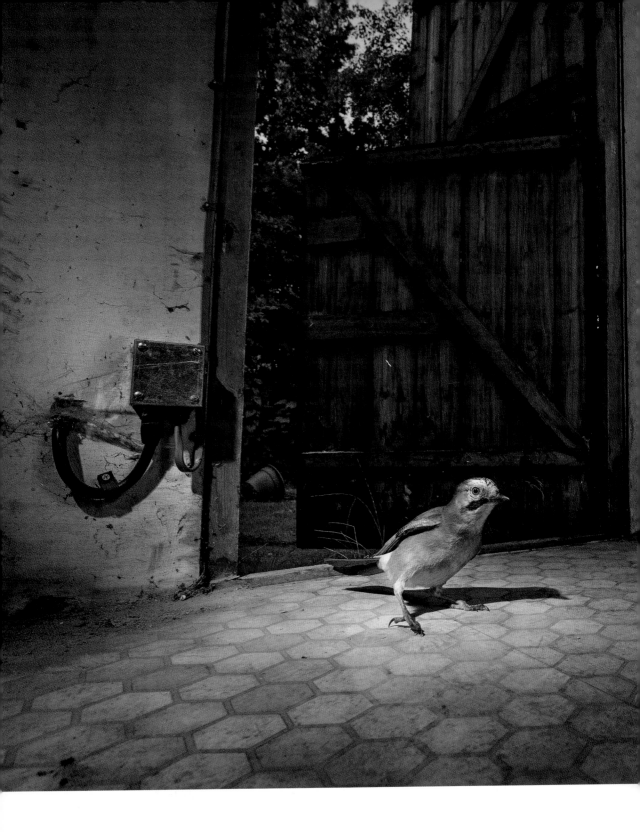

◀ **18mm, 1/250, *f*/8, ISO 200, PIR sensor, SB-28 (x2).** By using a wide-angle lens and setting up a PIR sensor, enabling the jay to trigger the camera when it landed in a predetermined spot, a far more unusual and ultimately interesting image of the same subject was captured. This image both tells a story and provokes questions from the viewer. Why is it there? What is it doing?

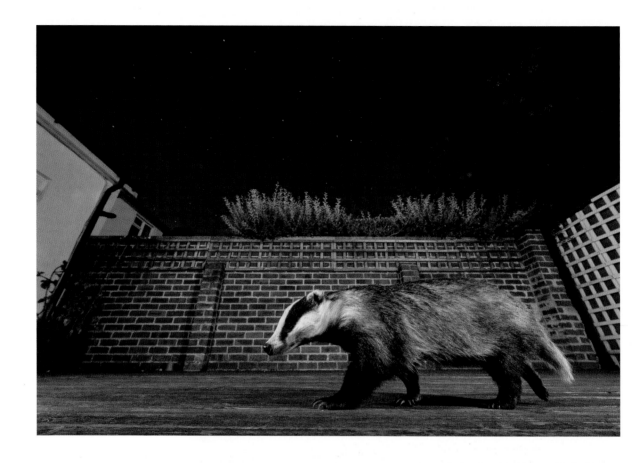

▲ There's plenty of distortion from this low, wide angle, but it gives an interesting view of the badger from eye-level perspective.

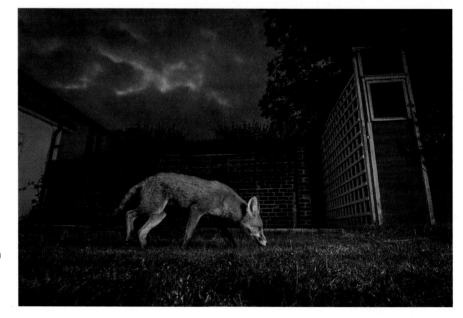

▶ There's no doubt that experimenting with camera placement and angles of view gives unique views of the world.

# EXPERIMENT

While sticking to the guidelines outlined here will set you on your way to taking more diverse and aesthetically pleasing photos, it's always worth experimenting from time to time. There is no need to always conform to the safety of predetermined ways of framing images. Occasionally, going against the grain is what can add the required extra dimension an image needs to make it stand out from the crowd. There are times when negative space being too much, the subject being cut out of the frame a little, or even not being in it at all (see page 146), will be the surprising parts of what makes an image work.

I always ask myself the same question when I look through the viewfinder. What's important to the image? Is it the eyes, a specific element, placement within the environment or some other quirky detail? Of course, I don't always know straightaway what those answers are, so a good trick is to turn on Live View and move the camera around the scene, to try different angles and distances. See what works or looks unusual on the LCD, especially from angles that make it hard to look through the viewfinder. Once an idea starts to form, work out the finer details from there.

Of course, there will be times when the safe shot is the only one that's available, and in those situations, it never hurts to make the most of it. But when the opportunity does arise, experiment, and see where it takes you.

► ▼ Switch on Live View and move the camera around at a different angles and heights, to get ideas for framing in positions that prove tricky to observe by looking through the viewfinder alone.

# LIGHT IS PRIMARY, SUBJECT IS SECONDARY

**Good light makes or breaks a photo. While the subject can be important in some contexts, it's crucial not to get hung up on *what* you're photographing and instead concentrate on *how* you are photographing it. Doing this will make a bigger difference to the quality of your images than you might first imagine.**

## WHAT IS GOOD LIGHT?

As the phrase goes, it's all about the light. However, the phrase doesn't say what that light is. You may think it refers to the golden hours at the start and end of each day, but this is not the whole story.

'Good' light is simply that which will give you a specific type of image. The trick to using light effectively is to understand what will and won't work in any given situation, and how you can apply that knowledge. With that understanding, any quality of light potentially becomes good light to photograph your subjects in.

When I first turned my attention to the backyard, I had no idea just how fortunate I would be with what would visit. However, we all have different wildlife on our doorstep, so it is really important to understand that any subject is open to being photographed nicely. I'd go so far as to say the more ordinary the animal, the more potential there can be to take photos that stand out and catch the imagination of your audience.

My approach to photography, and in fact most things, has always been primarily about aesthetics. I try not to get hung up on *what* I'm photographing. The subject is secondary. Throughout my project, a pair of wood pigeons living in a nearby tree became quite interested in what I was doing (or perhaps, more specifically, in the peanuts that had started to appear). This provided me the opportunity to turn my camera on them and demonstrate a phrase I've long stood by:

***I'd rather a pigeon in good photographic conditions, than a rare subject in poor ones.***

Pigeons aren't the most popular birds; they're ignored by many photographers, and are certainly not sought after. Nevertheless they can be photogenic and full of character with their whimsical expressions. I've certainly had great fun with them over the months, which is why I'm using them as the subject of choice to illustrate the points raised in this section.

I noticed the sun would filter through the nearby trees and create wonderful dappled light on the shed roof during the summer months. So, each evening for several weeks, in the last hour of daylight, when the sun came around far enough in the sky to throw that beautiful dappled light on the shed roof, I would set my lens up at height in the back half of the kitchen, with the French doors open, so I could shoot from the right distance.

The pigeons were also on the roof at this time, which necessitated getting a stepladder out so that I could see through the viewfinder. Friends who visited raised their eyebrows at this furniture choice!

◀ It doesn't matter how odd the scenario. If you need to do something to get the best light, always do it. The quality of your photos will be your thanks.

## PIGEON DISTRIBUTION

Pigeons exist just about everywhere, in one form or another. The wood pigeons featured in this book are common to western Europe; similar species exist almost worldwide.

Wood pigeons are shy, but they can become tame. You can see them all year round in fields and woods as they search for food, which can be crops like peas, grains and cereals, but also buds, shoots, seeds, nuts and berries.

# THE DIFFERENCE OF A FEW MINUTES

A vital rule to follow regarding light is:

**When the light is good for the shot you want, always make the most of it, immediately.**

Grab your camera and head out whenever the opportunity is there. This is a lesson I have learned the hard way over the years, missing images that I've seen the potential for because I've been doing something else, or been on my way somewhere and haven't wanted to stop. It's a big mistake. Always take the opportunity when it presents itself. Always. When you are shooting at home, there is absolutely no excuse not to take the shot.

Just how important this lesson is, and how dramatic the difference can be in images taken just a few minutes apart, is demonstrated by the two images of the same pigeon perched on a simple piece of wood shown here.

The photograph opposite was taken first, with the sun low in the sky, coming in from the left of the frame. The foliage at the end of my garden was thrown into shade, and there was a large difference in dynamic range between the foreground and background light. By dialling in 2 stops of underexposure, I retained detail in the pigeon, which was perched in the light, while rendering the background black. The side light emphasises the contours of the bird, giving it shape and texture. Without this, it would have looked like nothing more than a cutout of a bird stuck on a black background.

Not long after, the sun dipped behind the distant trees, which resulted in the entire yard being cast into shade. With everything being lit evenly, the image looks completely different. The impact is lost, there is no drama, no mood, and the photo, although nice enough, is ordinary and forgettable.

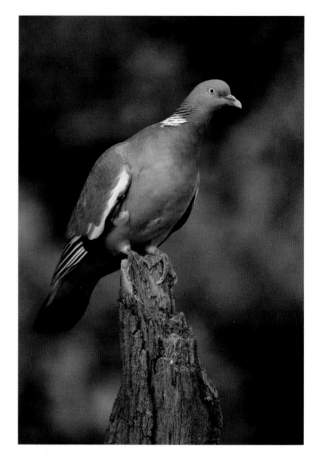

▲ ▶ The difference of a few minutes can be all it takes to lose a good image. The photo on the facing page was taken with the sun low in the sky, casting a beautiful, warm, dappled sidelight, and throwing the background into dark shade. In the photo above, taken just a few minutes later, the sun had dropped behind distant trees, creating flat, even light, and the mood was lost.

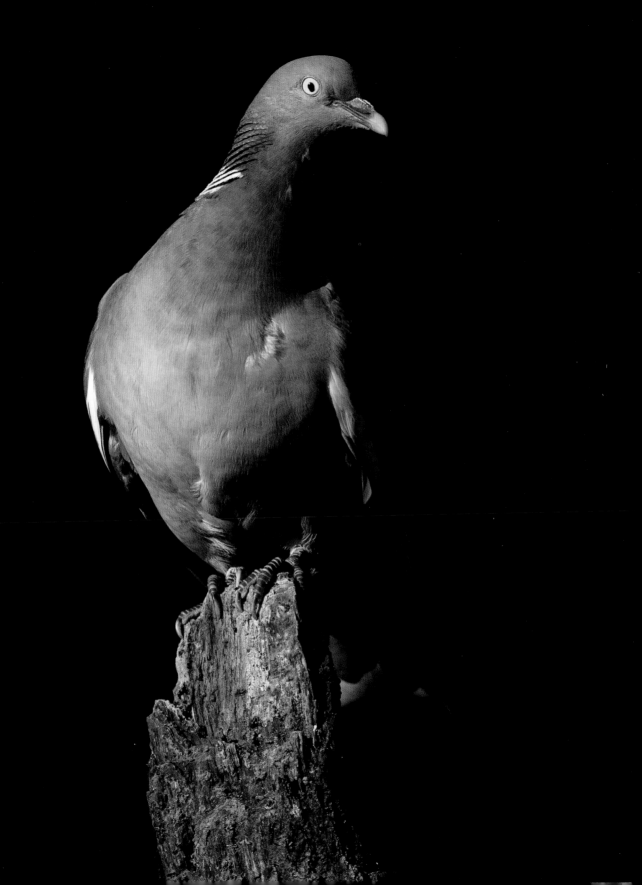

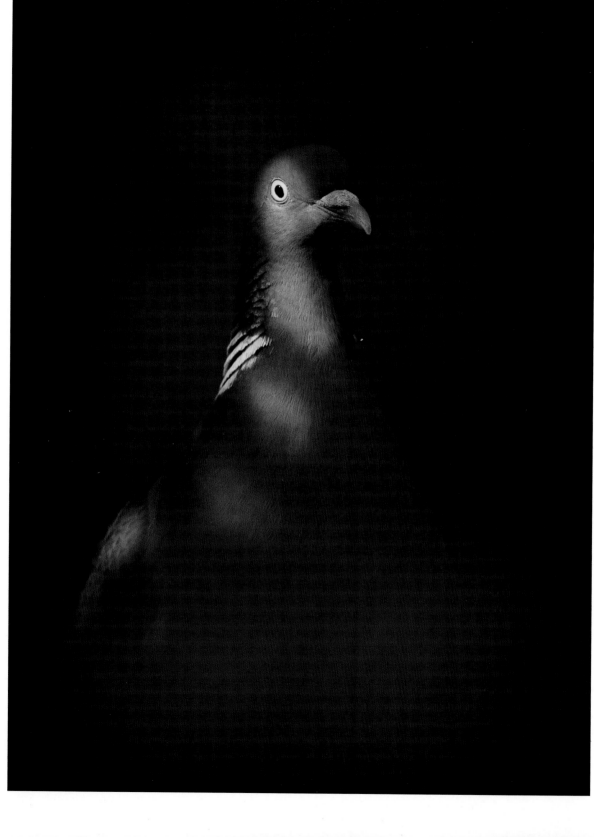

# CATCHLIGHTS

The eyes are an incredibly important feature in almost any photo of a living creature. Of course they must always be sharp, but even if perfectly in focus, without a catchlight – a highlight or reflection of a light source – the animal can appear lifeless. This means that you should always try to capture a catchlight in the subject's eyes if possible. Such a small detail may seem insignificant, but you'll discover that however beautiful the subject is or how amazing the conditions are becomes irrelevant when you're lacking that gleam of life.

# EXPERIMENT WITH LIGHT

## BRIGHT LIGHT

- Up your shutter speed and freeze motion. For example, if you have visitors to your bird bath in the hot summer months, capture birds flying to and from a feeder, or freeze water droplets exploding into the air.
- Underexpose for lighter subjects and wait for them to be all, or partially, in the light. Try to position yourself so that the background is in shade to further enhance the subject.
- Use sidelights to add drama and emphasise shape and contours.

- Place the subject between you and a low sun to create backlighting, or underexpose and frame your subject against a bright sky to create strong silhouettes.
- Keep the sun in the frame with a wide angle, and open your aperture to its smallest setting, such as $f/22$, to create a starburst.

# OVERCAST LIGHT

- Reduce the ISO to allow a slower shutter speed, and pan with a moving subject to show their movement in your images.
- Overcast light is good for capturing detail that is otherwise lost when the light is bright and full of contrast. This is especially true of darker subjects.

# ARTIFICIAL LIGHT

It is of course also possible to supplement, or even replace, ambient light with artificial light. As you progress through the following pages and into the later chapters, you will see how this became quite a big part of my own project. It can be used in some very creative ways to produce images that might otherwise not be possible with ambient light alone.

◀ The eyes are one of the most important parts of an image. Ensure they reflect a catchlight to help give some life to the subject.

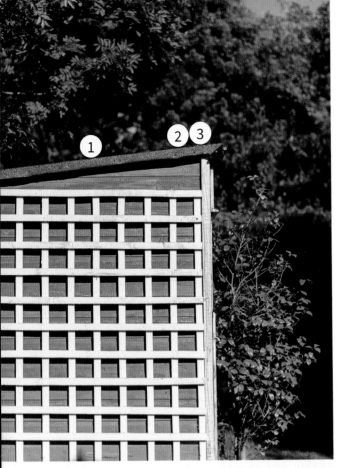

## WORK THE LIGHT

Even with the subject in the same position, you can work the light to achieve multiple results. Taken from different positions on my shed roof (see left for 1, 2 and 3, and overleaf for 4 and 5), the five pigeon photos shown here demonstrate the variation that can be achieved with different lighting. Some of these images can only be achieved during specific months of the year, based on where the sun tracks across the sky and at what time of day.

▼ **600mm, 1/640, ƒ/4, ISO 125, underexposed 3 stops.**
I waited for the pigeon to walk into pockets of dappled late-evening sidelight for this shot. Underexposure was required to maintain the correct exposure in the feathers, which naturally threw the shaded background into darkness. This shot is only possible from mid-June into early July, after which this lighting scenario is gone.

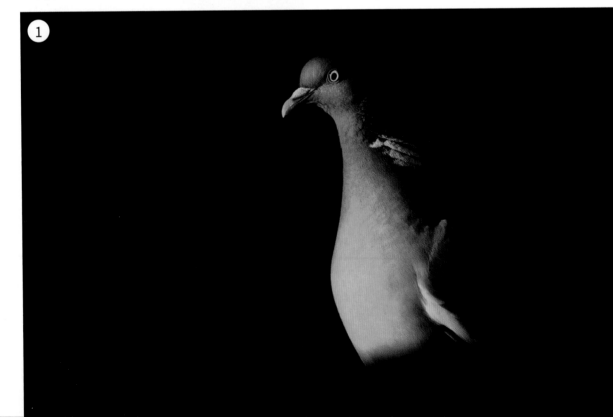

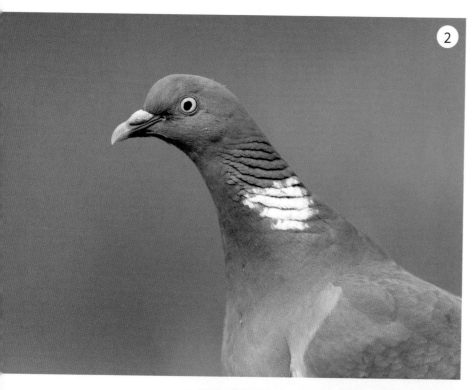

**◀ 600mm, 1/400, ƒ/4, ISO 400.** With the scene evenly lit on a cloudy but bright afternoon, a standard portrait with nice detail and a clean, contrasting background is achieved. Cloud cover on a bright day acts as a giant diffuser, allowing you to maintain information in the highlights and shadows. Fur and feathers always benefit from this type of light.

**▶ 550mm, 1/400, ƒ/4.5, ISO 400.** This was taken from almost the same place as the picture above, but in completely different light and weather conditions. The dull light works well with the wet subject to enhance detail. With the distant green foliage dimly lit, it allowed the rain drops to stand out, adding to the mood and atmosphere.

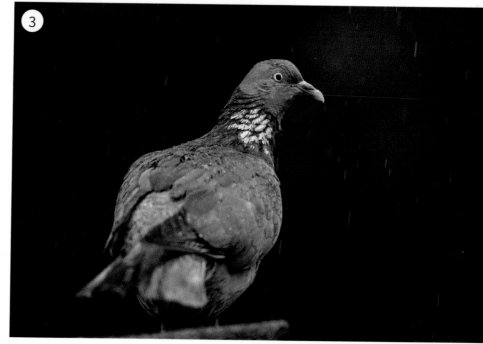

▼ **400mm, 1/640, *f*/8, ISO 400, underexposed 4 stops.**
The house roof looming behind the shed, combined with four stops of underexposure, ensured all but the brightest light, catching on the outline of the pigeon, was rendered black. In the resulting image, the light filtering through the beak adds a splash of colour and focal point. In my yard, this is possible only in early August, when the sun is between the two roofs as it sets.

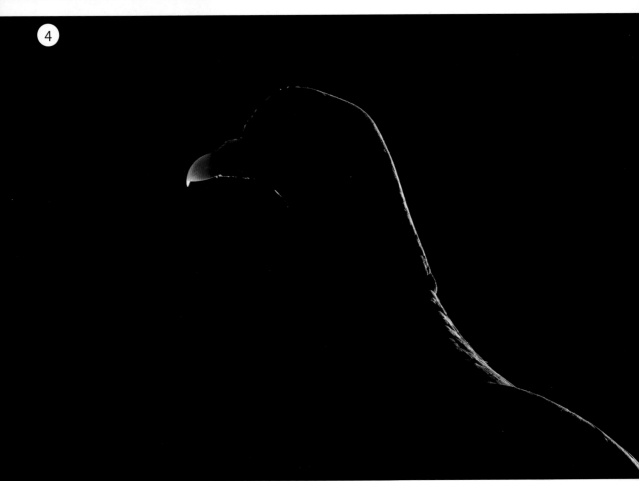

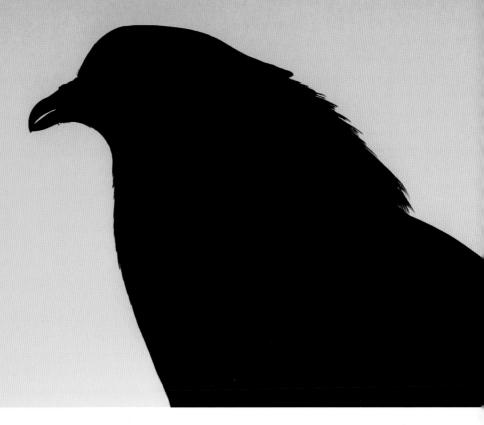

▲ **400mm, 1/1600, ƒ/9, ISO 64, underexposed 3 stops.**
Using almost the same setup as position 4, but standing
a couple of feet to the side, enabled me to frame the
pigeon against the sky and its warm late-evening tones.
Underexposure then helped to produce a crisp silhouette.
A large depth of field also helped ensure the outline was
sharp, and waiting for the beak to open slightly added the
finishing touch by breaking up the solid dark shape.

# UNDERSTAND & PLAN

I can't stress enough that instilling within yourself the attitude that reading the light, and understanding what you can achieve with it, is far more important than worrying about the subject that is in that light. One of the biggest misconceptions, that a particular light is 'bad', should be replaced with the notion that only the circumstances are bad for a *particular shot* you may be trying to achieve. If this is the case, look around and try to see how you can work the situation to your advantage. Change lenses or change shutter speeds, or play with the aperture. Essentially, assess the conditions and then plan how best to approach them.

There may not be a shot there every time, because the light and the subject need to come together in some shape or form for that, however I am almost certain that more often than not there is an image to be had. Even when you first might assume there isn't.

Just remember, it doesn't hurt to have a few ideas planned out in your mind, and knowing what light conditions you need for them means you can react quickly should the opportunity arise.

That said, although there is always something to be said for having an idea in your head, the best images are often the ones that are not planned. Those chance situations, conditions or encounters that present themselves unexpectedly. Moments when all the ingredients fall into place.

When you are able to read and react to those times, position yourself, frame the shot and work the light, you'll see a huge increase in not just your number of 'keepers' but also their quality.

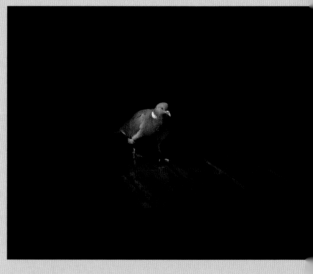

▲ **1/250, ƒ/8, ISO 64, SB-28 (x2), PIR sensor.** While natural light offers excellent photographic opportunities, when you introduce artificial light, you can sometimes create images that would not otherwise be possible, such as the spotlight effect seen here. Do not be afraid to experiment with lighting to inspire your creativity.

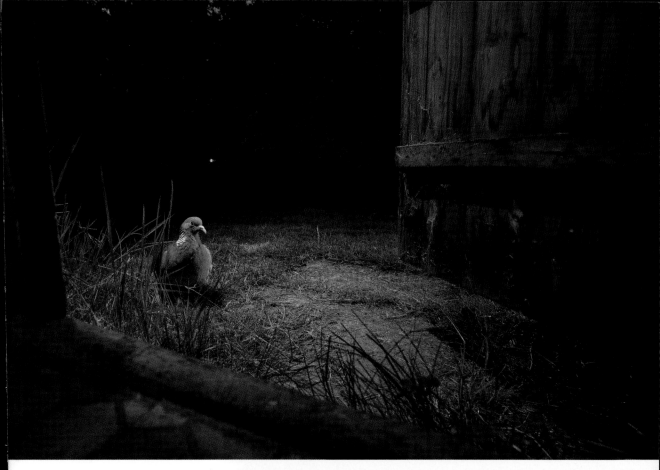

▲ **18mm, 1/250, ƒ/5.6, ISO 400, SB-28 (x3), PIR sensor.** Ordinary, everyday scenes can be transformed with a little creative lighting. Instead of thinking big in the frame, think small. Incorporate the surroundings and try something different. The pigeons often walk around my lawn, so here I've added a human element with a view of them from the open shed doorway.

▶ **50mm, 1/250, ƒ/11, ISO 64, SB-28 (x1), PIR sensor.** Placing the camera at an unusual angle works here, because it has been combined with a flash which is providing sidelight. This exaggerates the shadow, which reveals the shape of the bird. Without the shadow, this perspective would be unflattering and would not work.

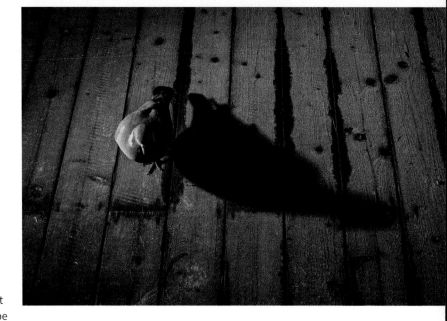

# UNDERSTANDING YOUR EQUIPMENT

**Accessibility is a key advantage of photographing wildlife at home, since most of us live somewhere with some form of outside space either attached to our home or nearby. Ideally, the accessibility of photography in such a location should extend to the equipment as well. A big part of this book's premise is to inspire you to photograph the subjects that appear in your own yard and help you learn enough to do so, but there's little point in this if it relies on the use of equipment that costs as much as a small family car.**

If you already own that type of gear, that's great. However, if you don't, it's important not to get hung up on it, because with some knowledge and a little thought, whatever camera and lens you already own should be enough to get you good results.

It is far more important to know, armed with a proper understanding of light and compositional techniques, how to make the most of the equipment you have, than it is to buy new gear in the hope that it will make a difference to your photos. The best camera in the world will not produce a good image without some form of knowledge and a little creativity. This is why I have placed this section after those on understanding light and aesthetics: because those who think the way to an improved portfolio is to buy the best camera gear are at a disadvantage and doing themselves a creative and financial disservice.

## CONCENTRATE ON WHAT IS IMPORTANT

Throughout this project, I used five different Nikon DSLRs. These include a bottom-of-the-range, entry-level camera, right up to the most feature-rich flagship model. Similarly, the lenses I used ranged from a simple 50mm prime to a high-end telephoto.

I have elected not to specify which bodies or lenses I used for each image in the book, but have given only relevant focal lengths and shooting data. This omission is deliberate and intended to emphasise the point that you shouldn't place too much importance on your gear. It is better to focus on what makes a picture work well, and what settings can be used to achieve the results. Photo agencies and magazines do not care which camera you took a photo with, only that it has a high enough resolution and is sharp enough to print. Similarly, when looking back over some of the most iconic wildlife images of the last 20 years, which camera was used to capture them is irrelevant; instead we take each image on the merit of its content. In five years' time, the cameras used here will be considered old (two of my bodies had already been discontinued well before writing this book), but the important information – the settings, composition and principles behind each of the images – will remain timeless.

With a little bit of planning, almost any kit will get surprisingly good results. It's a case of understanding how to use what you have, rather than wanting to use something you don't have.

Photographing wildlife at home gives you an opportunity you may not readily enjoy elsewhere within the world of wildlife photography: you can return to the location repeatedly if conditions such as the weather aren't as desired, or if the subjects do not cooperate.

Such an opportunity guarantees that you can learn and play to the strengths of your camera equipment, no matter how humble the pedigree.

## CAMERA BODIES

There is a huge range of DSLRs on the market, catering for all budgets and skill levels. Of course, lower-end bodies come with fewer features, slower focus, less-capable high ISO performance, and so on. While such compromises could ordinarily impact you quite heavily, when taking photos at home, you have the luxury of being able to work around those limitations with more ease.

That's not to say that you can easily achieve any type of image with any camera, because of course it's inevitable that some features and specifications make it easier to achieve certain results. The accessibility of your own backyard, however, allows you to push the limit of what your current gear can do.

▲ It's easy to want the latest and best camera, but don't fall into the trap of thinking better a camera will automatically mean better results. Even the most basic models of DSLR will be more than capable of achieving beautiful results if you know how to play to their strengths rather than worrying about their limitations.

## FULL-FRAME VS CROP SENSORS

A dilemma for many is whether to move to a full-frame sensor or not. DSLRs with full-frame sensors come with a much higher purchase price and are generally quite well spec'd but, while it's true they offer better build quality and higher ISO control, they can sometimes be disadvantaged by their smaller-sensor counterparts, due to something known as the crop factor.

The 'crop factor' is an apparent increase in magnification, or comparatively smaller field of view, that comes with a smaller sensor. For example, a sensor such as those in Nikon's DX range offers a crop factor of 1.5x, because the sensor of this camera is 2/3 the size of a full-frame model. This means a lens with a focal length of 400mm would provide the same field of view as a 600mm lens would on a full-frame sensor.

This crop factor is an advantage in wildlife and macro photography, where subjects will be larger in the frame than they would be with a full-frame sensor. The disadvantage comes when trying to take wide-angle shots, because here the crop factor fights against you. An 18mm lens would offer the same field of view as a 27mm lens, used on a sensor with a 1.5x crop factor versus a full-frame camera, making wide-angle shots harder to achieve.

## LESS NOISE ABOUT NOISE

So, what about noise? Full-frame offers better low-light capability, so they must be the best cameras to buy, right? Well, technically yes. In reality, no, not entirely.

It's important to expand a little on the subject of high ISO, as it's by far one of the biggest concerns for many photographers. There are some who don't like to shoot in the upper limits of the ISO range of their cameras for fear of the digital noise this can create; or conversely, are obsessed with buying the latest and greatest just to get the higher ISOs clean (I hold my hand up to once being such a photographer). The statement, 'If the light's not good enough for a lower ISO, it's not good enough to take a picture,' is one I've heard many times. For more about working the light you have, see page 24, but what I'm trying to get at here is that high ISO and noise aren't necessarily the deal breakers that many would have you believe them to be, so don't be afraid to up your ISO if the light requires it. Of course, if your end goal is to print enormous photos, then a high ISO shot might require more processing to get it looking its best when viewed large. For our purposes, I'm going to assume that the average person, if they are printing at all in this digital age of photo sharing, Facebook and Instagram, doesn't print larger than poster size at most.

The trick is to not be fooled by viewing your images at 100 percent magnification, or 1:1 pixel ratio on your computer screen. The noise might look quite unappealing when you do this, but as a friend and respected photographer once pointed out to me, looking at images that way is like viewing a huge print on a wall, inches from your face. Nothing is going to look its best when viewed like that. You need to step back, or zoom out, and see the picture in its entirety to do it justice. In doing so, the noise becomes harder to see and the detail comes back. Additionally, both in typical printing sizes and when downsizing images for web use, noise becomes far less visible anyway, so much so that you can lose a stop or more of apparent high ISO noise. Photo-editing software, such as Adobe Lightroom CC, is also incredibly good at removing noise, making the issue even less significant. It is true that dynamic range decreases as the ISO goes up, meaning it is harder to recover extreme differences in shadow and highlight information, but the way I like to think of it is:

Assuming the correct exposure and a pleasing composition have been achieved, I'd rather a photo with some noise in it, than no photo at all.

# MAKING THE MOVE TO RAW

This is a topic could span an entire book all by itself, but I will just touch on why shooting in Raw is preferable to JPEG, especially for those who are yet to take the leap. While it's true that shooting Raw requires learning how to use editing software to make the most of it, in the long term this will be far more rewarding than replacing your camera because you aren't happy with its image quality. Even if you are happy with your camera, but have been shooting JPEG, switching to Raw will give you a whole newfound love for the images it produces. The secret of Raw files is that they retain all the data from the sensor, allowing you far greater control at the processing stage. This also explains why Raw files take up more storage space: they hold all that extra data. A JPEG, in comparison, throws away all the data that isn't being used, which gives you a smaller file, but one that has far less tolerance for recovering shadow and highlight detail, or tweaking the white balance, among other things.

Think of it like this: imagine a Raw file as a Word document and a JPEG as a printed copy of that document. If you spot a typo and want to make a change on the printed copy, you'll have to change it manually using correcting fluid and a pen, which then won't look as good as it did originally. In addition, if you want more copies, you'll have to make a photocopy, which reduces the quality of the document further.

However, if you still had the Word document (Raw), you could just open the file, change the typo and print it again as many times as you like, all in perfect, original, quality.

▶ ▲ Shooting in Raw isn't as scary as it seems. Doing so allows you far more control at the editing stage, enabling you to regain and enhance highlight and shadow detail to a far greater degree than shooting in JPEG does. Turn off ISO noise reduction when shooting in Raw; in-camera noise reduction only really benefits JPEGs, and if an image requires cleaning up, photo editing software offers better control of how noise is handled and removed.

## THE 'GET IT RIGHT IN CAMERA' RED HERRING

We've all heard someone say, 'I like to get it right in camera and do as little processing as I can'. Such an ambition is very noble, since of course the fundamental building blocks of the image must be right. We *should* all strive for the image to be as accurate as possible to our vision, by way of proper use of shutter speed, aperture, ISO, white balance, framing, and so on.

I believe, however, that the ideal of applying no editing to images after the fact is largely a fallacy. It is an argument that I've heard many times over, and while those building blocks are essential as the basis of a photo, the notion that this should also extend to shadow detail, contrast, highlights and vibrancy, for example, is flawed from the start.

The reason for this is simple. If you shoot in JPEG, your camera adds a preset amount of sharpening, noise reduction, contrast and so on when it processes the JPEG to give you the end file. An image straight out of the camera has, therefore, already been processed, but using only a very simple set of parameters. Thus there is no such thing as an image that needs no processing, because even one that has come straight out of the camera has already been processed. So, why let your camera do that basic editing of your files, especially noise reduction for poorer high ISO models, when you could do a far better job of it yourself using editing software such as Lightroom or Photoshop? You can restore details that may have been suppressed,

or make small tweaks to individual frames rather than have the camera apply identical settings to every frame. It's information that the sensor has made available to you, so why not use it?

**The essential thing is not to overdo image editing, rather than to not do it at all.**

What has all this got to do with shooting Raw versus JPEG? The answer is simple. Switching to Raw will give you far more scope to edit your images, and in most cases produce a far better result than a straight-from-camera JPEG. So much so that it may well help get you out of the 'I need a new camera to take better-quality photos' mindset, at least for a while.

The important thing to keep in mind is that if any aspect of your camera isn't as good as you would like, you can still try to work around these limitations. For example, to minimise noise, concentrate on shooting on bright days and consider moving any feeders or plants that attract wildlife to a sunnier position in the garden. While it might limit when you can shoot, the advantage of working at home makes it possible. Think creatively, maybe drop the shutter speed and use a tripod to keep the ISO low, and experiment with panning techniques.

Ultimately, I am an advocate of doing whatever you can to squeeze every last bit of quality and function out of your camera before you upgrade, until you encounter limitations that prevent you from growing further as a photographer.

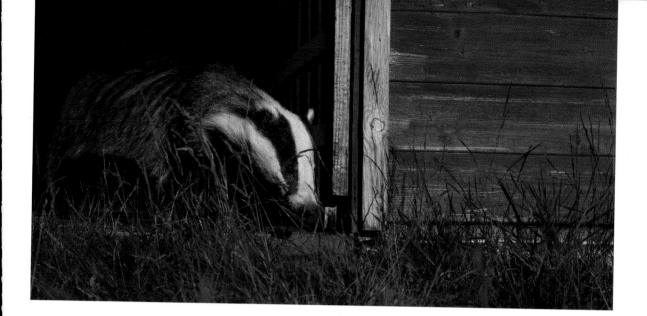

## LENSES

As with camera bodies, any lens can be used to photograph wildlife in the garden. Telephoto lenses are generally associated with wildlife photography, and although they are impressive, you don't need one to be able to capture beautiful images. Wide-angle lenses, mid-range zooms and of course macro lenses all play their part in wildlife photography, and this is just as true in your backyard as out in the wild. In fact, it may be even more true, since the wildlife in your garden should be more accustomed to the presence of humans, making it a little bit easier to get them on camera with those shorter focal lengths.

If you are ready to upgrade your equipment to achieve higher-quality images, a better lens will give you more for your money nearly every time. Again, however, it's important to not be too preoccupied by what you currently have.

▶ Wildlife photography isn't just about the biggest lenses you can get your hands on. The shorter focal lengths can be just as powerful a tool for capturing images that command attention.

▲ **1/250, ƒ/8, ISO 400, SB-28 (x2), PIR sensor.** Using smaller, wider lenses, such as a 50mm prime, allows the camera to be closer to the subject, giving a sense of its place in the environment by showing the surroundings.

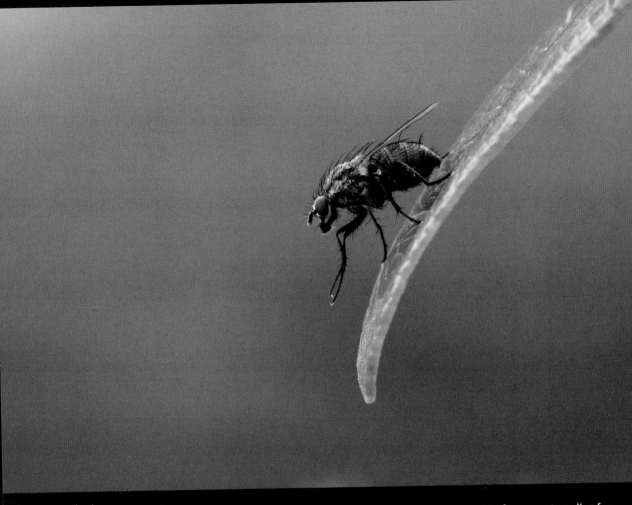

▲ **150mm, 1/320, ƒ/8, ISO 800.** If you are struggling for subjects or inspiration, think small. Even the smallest of outside spaces could be hiding some fascinating creatures, right under your nose. With a macro lens, even a hanging basket with flowers could be a photographic goldmine.

# THE ART OF BACKGROUND BLUR

If you are shooting with longer focal lengths, lenses that offer fixed apertures of *f*/2.8 and below are commonly referred to as 'fast'. This is because they let more light into the camera through their larger apertures, allowing for faster shutter speeds in any given light level, than a lens with a smaller aperture, such as *f*/6.3.

Faster lenses also allow for lower ISO levels and offer superior sharpness. These are valid reasons to use them (although again, it is not worth worrying too much about the ISO/noise debate). One of the big selling points of these lenses, however, is the shallow depths of field that comes with smaller f-stops like *f*/1.4 and *f*/2.8, diffusing the background and making the subject pop from the frame.

It's very important to understand that there is more to achieving those beautiful diffused backgrounds than simply having a fast lens with a large aperture. The trick doesn't lie only with the lens; it also comes down to the distance relationship between you, the subject, and the background; the aperture simply dictates what those distances should be. The smaller the f-stop (the bigger the aperture), the closer the background can be and the farther you can be from the subject, and still get that beautiful background blur.

If your yard is long enough to allow it, and you can get sufficient separation, even shooting at *f*/8 will give you the clean background you desire to make your subject really stand out and pop from the frame. Photographers using fast *f*/2.8 and *f*/4 lenses will often shoot at *f*/8 anyway, in order to ensure they get the whole subject in focus.

If your yard-and-lens combination does not allow for enough subject separation, you can help create a more evenly toned backdrop by draping a natural-coloured sheet or camouflage netting in the background. That said, achieving it naturally should be attempted first.

▶ Apertures less commonly associated with clean backgrounds such as *f*/6.3 and upwards can be made to work well, with a little knowledge and planning.

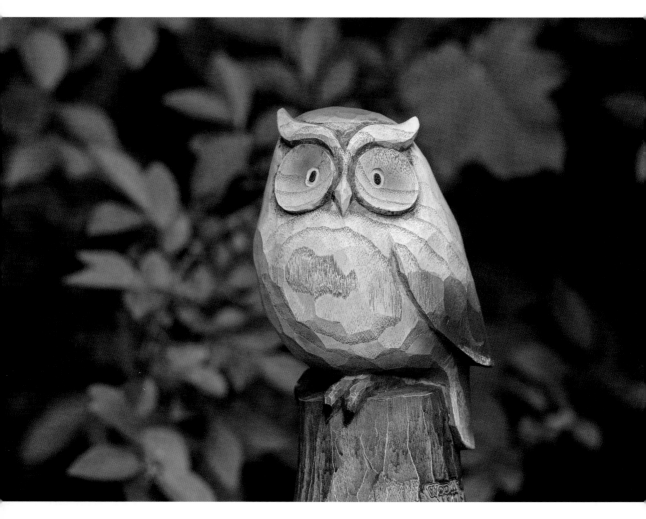

▲ **400mm, 1/320, ƒ/8, ISO 800.** Successful subject
separation is down to several factors – the aperture of
the lens is just one aspect. The subject's distance from
the background, and your distance from the subject, are
equally important. With the background just a few feet
away in this shot, too much definition remains, which
creates distraction and makes the frame feel cluttered.

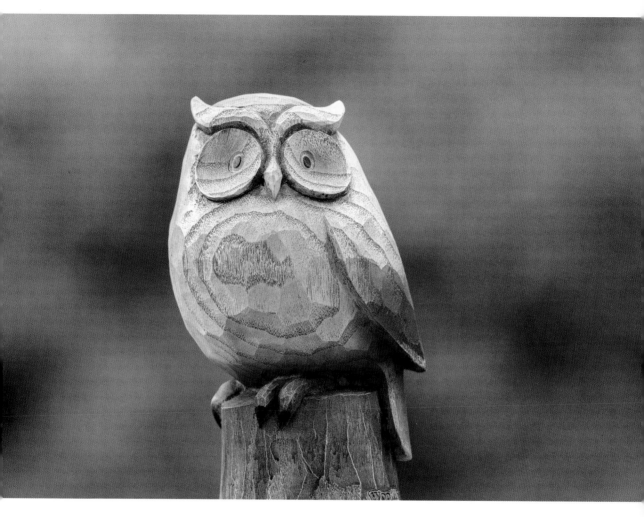

▲ **400mm, 1/320, ƒ/8, ISO 900.** Increasing the distance of your subject from the background makes a big impact. Here, using the same small aperture as the image opposite has produced the desired clean, diffused, background. To achieve this, the subject was around 9 metres (30 feet) from the bushes beyond. It's not perfect, however: note the distracting dark patch bottom left – remember to always keep an eye on your backgrounds.

## THE SECRETS OF SHARPNESS

Sharpness is another reason why big telephoto lenses come at a premium. Optically, they are incredibly sharp, even wide open, allowing you to make full use of the depth-of-field advantage a large aperture offers. While it's true that variable-aperture zoom lenses aren't generally as sharp when wide open (i.e., at their largest apertures, such as $f/5.6$), most improve quite dramatically by stopping down 2/3–1 f-stop. For example, if you have a lens that covers a range of 80–400mm, and at 400mm its biggest aperture is $f/5.6$, then you would stop down to $f/7.1$ or $f/8$ for maximum sharpness. Remember that the smaller the f-stop, the deeper your depth of field becomes, so the more in-focus your background will become.

While pin-sharp images are desirable, much like noise, less-than-perfect sharpness won't necessarily show up at regular print sizes. This does not excuse or rescue a misfocused image or one that clearly exhibits hand shake – such images can rarely be saved. The point is rather that not having the sharpest of lenses shouldn't be an initial cause for concern. It is more important that you get the fundamentals of the image right: looking at some of the winners of several of the most prestigious competitions in the world will attest to that fact.

Another important point to remember is not to compare viewing your images at high resolution against others online, at web size. In the same way that noise appears reduced as you downsize an image, apparent sharpness increases, making even relatively soft photos look sharp at small sizes. I've lost count of the times I've seen comments online saying how 'amazingly sharp' someone else's images are and how they wish theirs were like that. Never judge images by the web-sized version.

▲ Whether the lens you use is a telephoto, wide-angle or macro, a tripod is essential. Always keep the legs as short as possible to increase stability.

## TRIPODS AND SUPPORT

Even the most expensive lenses can produce a soft image if care is not taken. Fortunately, you can do several things to help get the best sharpness from your lenses. I favour the use of a tripod to achieve maximum stability and support, and doing so is especially easy when shooting at home because the trouble of carrying one is not an issue when you don't have any distance to walk. Similarly, using a tripod avoids fatigue from lifting the camera for prolonged periods. It also allows you to set the camera up pointing to a specific area so that you know it's framed and ready to go when the subject appears. When using very slow shutter speeds with wide angles, in low light or using a macro lens, a tripod is all but essential to obtain sharp images. A shutter release cable will assist you further, since you can fire the shutter without touching the camera.

For the greatest stability, ensure the tripod's legs are splayed apart and set as low as possible. This is especially important if using a cheaper, lightweight tripod – even a mild breeze can introduce movement at high magnification levels or with close-up subjects.

For ultimate camera stability when using long lenses without a tripod, and to remove camera shake almost entirely, use a beanbag for support whenever possible. Maximum stability comes from those with a heavy filling such as rice. Although weighty, this is not a problem when working at home.

▲ Never be afraid to improvise. This balanced pile of bricks is just one of various methods I've used to secure my equipment in the required position.

## VR AND SHUTTER SPEEDS

When hand-holding your camera, tradition dictates using shutter speeds at least equal to your focal length. If using a 500mm lens, therefore, a shutter speed of at least 1/500 second should combat any shake, while for 50mm, it would be 1/50 second. Built-in vibration reduction (VR) and/or image stabilisation (IS) combat shake, allowing you to use slower shutter speeds, but they won't reduce the appearance of subject movement. Always ensure that you use a fast enough shutter speed to freeze the movement of your subject.

## THE D.I.Y. BITS

Finally, some of the items that have proved invaluable to me have included plastic bags as waterproof camera covers, cardboard and gaffer tape as flash snoots, and sealable food bags as waterproof flash covers. Before I had the right equipment to hold my flashguns in position, I used a garden bench and even a rubbish bin to position them where required.

▼ You can spend plenty of money on props and accessories. Alternatively, a little imagination applied to what you have lying around can work well, too. This old bird feeder, which I'd discovered wedged behind the shed when I moved in, came into its own in combination with a piece of log, held in place with a spare house brick.

▶ My improvised bird stand worked well and enabled me to entice the beautiful jay seen here (and on page 19) into a position where I could capture a good shot.

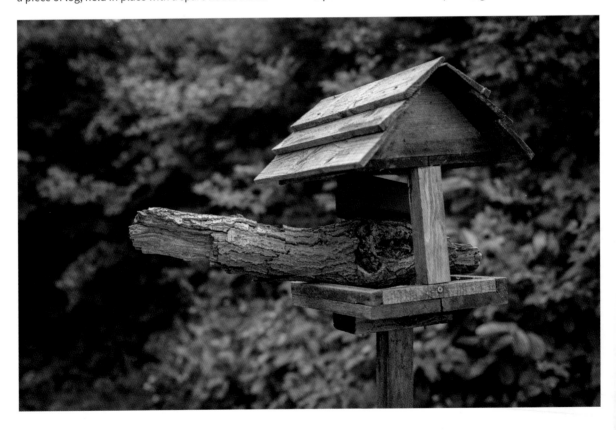

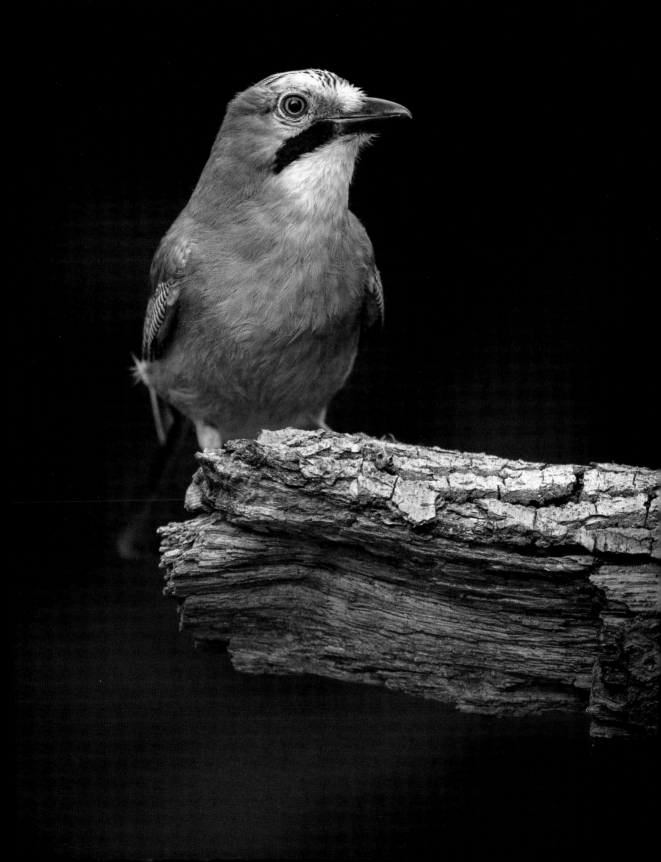

# CHAPTER TWO

# NEW BEGINNINGS

**A journey of discovery**

# ESCAPING CITY LIFE

**When I moved with my family to a new home, away from the concrete surroundings of West London that I had known all my life, out to the leafier county of Surrey, I finally felt at home.**

Until that time, if someone mentioned photographing wildlife in the backyard, my thoughts immediately turned to little birds perched on twigs waiting to fly across to bird feeders. However, unlike many, my photography didn't grow from a love of birds or birdwatching. While many beautiful examples of such photography exist, I have simply never felt a connection with the smaller birds of the world. Added to that, since I am not much of a gardener, I made every effort to ensure my previous yard was as maintenance-free as possible: all concrete and shingle, with no flowerpots or grass. I rarely even stepped out of the back door. I'm ashamed to say, as a wildlife photographer, I simply wasn't inspired by what I saw when I looked out the window. My thoughts were that West London was certainly no Africa.

When we arrived in our new home, initially my disinterest in the yard was much the same. The space, at around 12 x 6 metres (40 by 20 feet), was a little larger, and I could hear more bird activity, but photographic inspiration remained dormant.

Then, early in summer 2014, after the building work had ended and the yard was reclaimed as an outside space, some friends stayed for the weekend. That Sunday morning over breakfast, one of them mentioned having spotted a fox walking through the garden earlier. I quietly suspected it was one of the neighbour's cats, a ginger specimen that occasionally strolled through. Despite my friend being adamant, I assumed it unlikely that I'd not have spotted the local fox after living there for over a year. For the next couple of weeks, I paid a little more attention to the outside, and still I saw nothing.

More than a month later, I was sitting in the kitchen one grey lunchtime when I saw a flash of ginger tail out of the corner of my eye as it disappeared behind the shed. It was the briefest of glimpses, but I knew instantly it wasn't any of the local pets. I ran upstairs to look out the bedroom window and lo, there it was sitting on the grass in my neighbour's yard. That fox would prove to be the catalyst for not just my opinions of backyard wildlife photography changing, but also for an incredible journey and re-evaluation of my own photographic abilities. I snapped a quick image on my phone and the seed was planted: I needed to photograph this fox properly. With the possibility of doing so from home suddenly a reality, a plan slowly started to develop. Although wildlife photography is a tricky photographic genre to pursue – and I know this from many experiences of travelling, sitting, waiting, freezing, getting wet, being sleep deprived and everything else that goes along with it – I naïvely

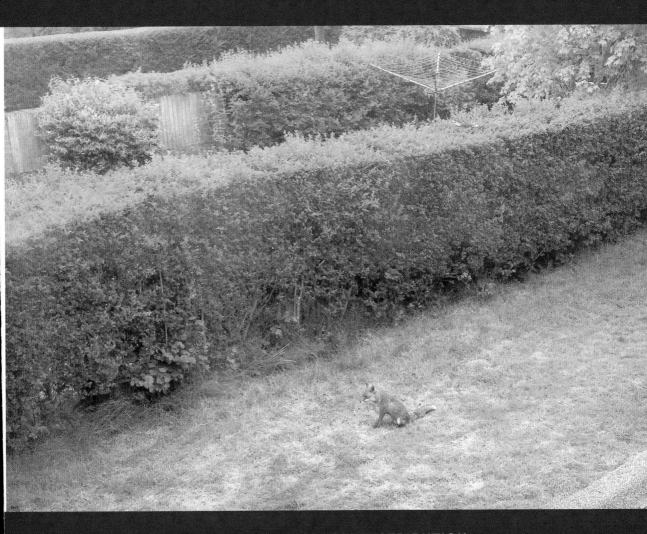

▲ Every project has to start with a first photo. For me, it was this picture of a fox, taken with my iPhone from the bedroom window.

## FOX DISTRIBUTION

The red fox seen in this book thrives throughout Europe, the US and Asia, but similar species are found all over the world – including the Arctic fox, jackals in Africa and South Asia, and dingoes in Australia.

Red foxes are widespread and common, with many living in towns. They are usually active at dusk and through the night, scavenging alone for food (they eat almost anything), though they live in family groups of one dog, one vixen and four to seven cubs.

assumed a fox in my garden would be an easy target. My plan was, 'Put some food out, and before long it'll practically be eating out of my hand'. This proved to be incorrect. As I discovered, when there was any indication of me being around, the foxes retreated very quickly. It appeared that in my new, more rural neighbourhood, the foxes combined the regularity of an urban fox with the skittish temperament of a rural one. Such caution is ultimately a good thing, since not everybody likes foxes (indeed they have the potential to cause much destruction and mess) and a tolerance to me could lead to them falsely assuming other humans will be as friendly and welcoming.

## THE EARLY DAYS

I started leaving dry dog food on an upturned flower pot at the very end of the garden. The food often sat there for days, little by little slowly disappearing. Initially, I never saw the food being taken. It wasn't a coincidence that when food started to be left out I also noticed a gradual increase in visits from the neighbouring cats, and one day I even caught a flash of white vanishing into the hedge, which turned out to be a neighbour's dog who'd caught wind of the treats on offer. I made an effort to close up the holes where the intruders were coming in, but these pathways were also being used by the fox. Was there a way to keep a dog out and give a fox access? No. Every time I heard the high-pitched yap of the little dog, I had to look out to ensure he hadn't come looking for goodies or, even more importantly, wasn't leaving me any goodies of his own! Finally one evening, about three weeks after I first started to put food out, I spotted a fox slowly making its way through the grass at the end of the yard. I watched with anticipation as the food was sniffed and then eaten. It was a great moment, and I knew then there was hope for me capturing these visitors on camera.

I hadn't really considered what sort of images I wanted to try to capture initially, other than one rule

that I was determined to stick with: I didn't want the photo to look like it was taken in a backyard. That rule required the grass to be long. Very long. Those who know me might tell you that this was just a cunning ploy to not have to dig the lawnmower out of the spider-filled shed, but I stand by the fact it was all done with artistic merit in mind. To keep the non-photographic demographic of the house relatively okay with my plans, however, a small compromise was made, and I started to cut the grass in the front half of the yard. Not often, but just enough that when the house started to resemble an abandoned building from the outside, I'd give it a brief cut to restore order.

Over the next few weeks, as the long summer days warmed up, I kept a close eye on animal activity in the yard. Time went on and steadily I began to see a gradual increase in fox visits, and occasionally two would appear during the very last light of the day. Middle-of-the-day visits were occasional at best, but one afternoon, I caught one of the foxes sleeping quite happily for almost two hours in the long grass at the very end of the yard, which was a sun-trap for a few hours. It was encouraging as well as frustrating, because these daylight visits would never result in a photographic opportunity.

Of the two regular fox visitors, the second was a lot smaller than the first, and it seemed likely that the pair were a vixen and her cub from a litter earlier in the year. Their sporadic visits continued, usually at last light, and always accompanied by the warning sounded by the blackbirds as they spotted danger heading towards them through the bushes.

Initially, the photographic opportunities presented were limited and less than ideal. I made do with trying to photograph the foxes through the closed French doors at the back of the kitchen because, using this method, they happily walked across the decking and came quite close to the house. The resulting photos were always high ISO and a little fuzzy due to the glass door between the subjects and me. So, when the

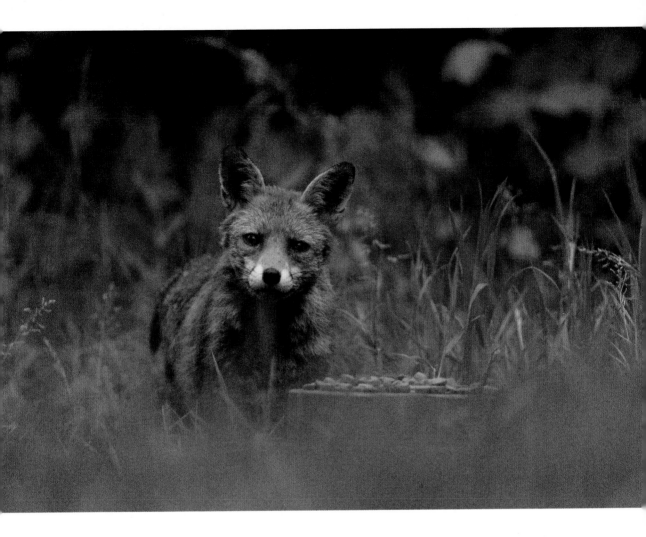

summer weather was on my side, I started leaving the French doors open. I set the camera up an hour before sunset, and to make sure I'd be in position if they turned up while the light was relatively usable, I'd lie at the open door and wait. To ensure my shape wouldn't scare them off, I even put the washing racks to good use by lying between or behind the drying laundry to conceal myself a little at the doors.

▲ 600mm, 1/250, ƒ/4, ISO 16,000 (equivalent).
After several weeks of waiting, I finally caught my first glimpse of the new visitors at dusk. Wary of any movement inside the house, they remained a significant distance away, staying within the safety of the long grass and nearby exits through the bushes. Shooting through the glass of my doors necessitated the high ISO, and the resulting visible noise.

▶ 600mm, 1/250, ƒ/4, ISO 14,368 (equivalent). In time, the foxes would come closer to the house, but my initial photographs were shot through closed French doors. With the foxes only appearing at dusk, and this extra glass barrier between us, the images I sought were almost impossible to obtain.

▼ As the summer rolled on and the fox sightings became more frequent, I started leaving the back doors open. I would lie in position around an hour before sunset and quietly wait for a dusk visit. To help disguise my shape, I used objects to break up my outline, such as lying down between racks of drying laundry.

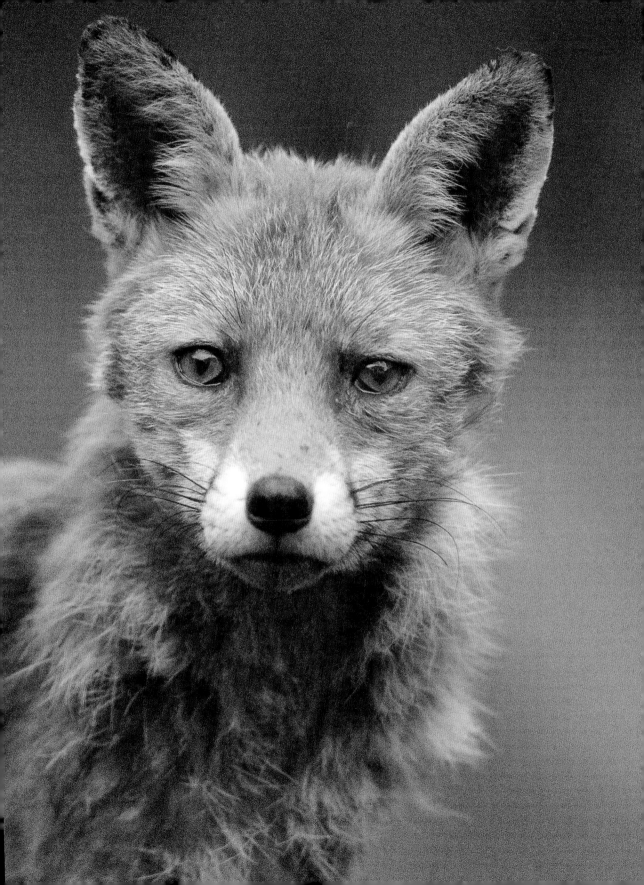

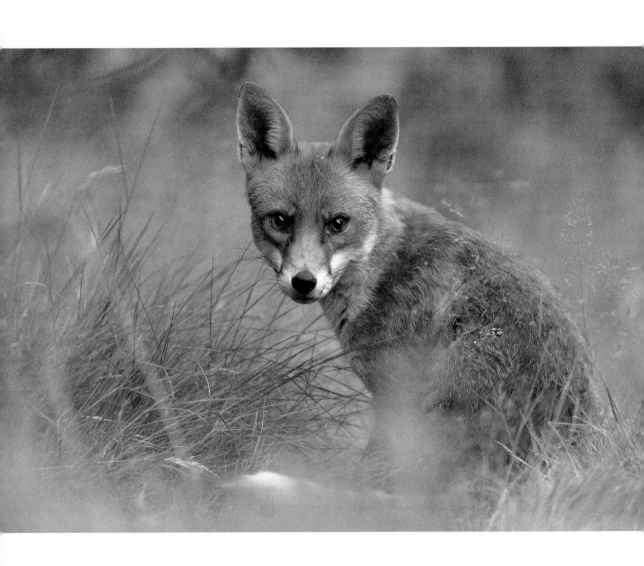

I continued to be frustrated, since although the visits became frequent, the foxes arrived mostly at dusk when the light was all but gone. Regardless, day after day I left my camera lying on a Skimmer Ground Pod (support), pointing out the back door, just in case. Over the course of that summer, it wasn't unusual for visiting guests to find me lying on the floor in the kitchen, camera pointed out the back door, where I would remain until the very last shred of light had gone. I only called it a day once shooting at an equivalent of ISO 25,600 would return lowly shutter speeds under 1/10 second.

Whenever an opportunity to take a photo presented itself, I noticed that even if I was lying inside the house, the sound of the shutter was a problem if the kitchen door was open. Unless the fox was at the very end of the yard, the noise of the camera would usually result in an immediate about-turn and exit from the yard. Even with the camera in quiet mode, it made little difference. This is one time where the lower end of the DSLR market can offer a definite advantage, as generally they have far quieter shutter and mirror mechanisms than those of their higher-end counterparts.

Around this time, Nikon released an update to one of their higher-resolution bodies, and with it came a quieter shutter mechanism. I was keen to see if this would have an impact on my ability to photograph the fox, so I was very eager to put it to the test come update-release day. That very night I lay in position and waited. As the light levels started to fade, my familiar visitor appeared. As I took a single frame, the fox glanced over but, crucially, didn't retreat. With the vixen now looking square down the lens at me I fired a second frame, sure that it would be the one to send her scurrying off into the bushes. It didn't. Instead, she had a little scratch, sat there for a few seconds just looking around the garden then eventually walked off. I was delighted. It was the first time a camera shutter hadn't sent her immediately rushing away.

Sadly, it proved to be one of the only decent opportunities I would get to photograph in daylight hours. Very shortly after that day, such daylight activity appeared to cease altogether.

◀ **600mm, 1/200, ƒ/4, ISO 6400.** It wasn't until seven weeks after my initial shot-through-a-closed-door image, that I was able to finally capture a single decent portrait of this beautiful fox with the back door open. It was the only opportunity I would get, but my vision of showing a fox in long grass finally came together, and made up for the months of letting the grass go wild.

# SECRETS OF THE TRAIL CAMERA

**The foxes' daylight visits spread further apart, and then seemed to dry up completely, an irritating situation, which seemed worse as I'd finally secured my first decent picture.**

I really thought I was on track for more opportunities, and I knew the next step was to maximise my ability to keep an eye on things, but I simply didn't have the time to sit in the kitchen all day every day. This led me to buy a Bushnell trail camera to enable me to fully monitor any activity.

Apart from an initial setback when I found that Quicktime on my iMac did not play the Bushnell's AVI clips (a download of VLC player saved the day), I discovered that having eyes on the yard at all times was, simply put, a revelation. What I first took to be an empty, quiet garden, in fact hosted a flurry of activity from the foxes, along with the more common subjects such as pigeons, squirrels, the occasional jay and some jackdaws. It was the fox activity, however, that really interested me. They no longer visited during the day, but under cover of darkness they were coming many times a night. One or two would often visit a little after sunset, eat the food left out, then come back several more times later that night. This led to a routine of me placing some food out in the early evening and then checking it again just before retiring for the night. If it was gone, I'd put a little more out. Just a handful at a time, but enough to keep interest up without the risk of introducing too much dependence. I quickly settled into a morning ritual of checking the camera footage from the night before over breakfast. There was something strangely addictive about having eyes on this new world that I had discovered right under my nose.

Those of you who already use trail cameras will understand exactly what I am talking about, but when I lived in London, I never thought I really had need for one. With hindsight, I now wish I had put one in my previous yard. If you don't already own one, I strongly recommend it – you never know what might be coming to visit your own backyard during both the day and night.

A week or so after installing the Bushnell, we went on a long weekend away to visit friends in Germany. Before we left, I placed a few handfuls of dry dog food around the garden. Additionally, to try and prevent the pigeons and squirrels eating everything, I spread some peanut butter over a small log. In this way, I hoped that there should be enough food dotted around to keep any visitors happy for the five days we would be away.

When we returned from Germany, I couldn't wait to see how active the garden had been. All signs of food were long gone and I could see the log had been licked clean of peanut butter. Eagerly, I pulled the memory card from the trail camera, noting as I did so that it was full. I made a cup of tea and fired up my iMac to start viewing the weekend's footage, and find out what the foxes had been up to.

# THE TURNING POINT

The first 20 or so of the 140 clips were of pigeons and squirrels stocking up on the more visible food sources. On the next, night had fallen. A few clips of the fox appeared, followed by a neighbour's cat. Then, as the next clip filled the screen, something unusual could be seen in the grainy footage. It had its back to the camera and for the briefest moment I thought it was just another cat, but then it moved a little and my brain clicked in to gear.

### I was looking at a badger!

I couldn't quite believe what I was seeing. Our first night away and this most unexpected of mammals had paid a visit. Badgers are a controversial species in the UK and get an incredible amount of bad press, since they are implicated in the spread of bovine TB. Sadly, this leads many to believe the most efficient way to decrease the risk of the disease being transferred to farmers' cattle is to back government-introduced culls to reduce badger numbers, by as much as 70 percent in certain areas. With all this negativity surrounding them, it was incredibly heartwarming to see one alive and well, and under no threat at all. Personally, I'd only ever seen a live badger once before; all other sightings were of those that had fallen victim to traffic on busy, fast-flowing country roads. I was elated!

I eagerly went through the remaining video clips from the weekend and was delighted to see this nocturnal visitor had returned every night, except for the last. I couldn't be certain of that, though, since there had been so much activity that the memory card had run out of storage space before the final evening. Suffice to say, I set the camera straight back up that night, and I could barely sleep with thoughts of the new discovery going through my mind, wondering where it had come from. Although I now live in a more rural location than I had previously, my home is still in what is essentially an urban area. Coincidentally, only a few weeks prior to this I had said to a friend, who has seen badgers in the woods behind her house, how much I wished I had one in my yard. Now I did!

Initially, I simply observed each night's activities. Alongside that, I also did something that I'll fully admit puts me in the realms of being a super nerd: I created a spreadsheet to keep track of the times the badger visited. Sometimes it was only once a night, on others it could be as many as three. Generally speaking, there was also a fairly regular time slot too, with most visits falling somewhere around 9–11 p.m., 1 a.m. and 3:30 a.m., give or take 30 minutes each way. It wasn't an exact science, but logging it like this was a good way to build up some form of activity pattern.

▼ Trail cameras are simple to set up and can be attached to garden objects such as fence posts. This makes them ideal for keeping an eye on wildlife activity when you can't.

During this early viewing, on occasion I observed a little interaction between the fox and the badger if they both appeared in the garden together. It was very amusing and insightful to see the firm pecking order in place. If the badger was already there, I'd see the fox lurking in the shadows. If a fox was on scene first, it'd always be keeping an eye out before being chased off when the badger arrived. It was like a mini soap opera each night, playing out as the world slept.

Over the weeks, besides the species interaction, on a couple of occasions I also glimpsed two badgers together. They were quite playful at times, chasing each other around, and appeared to be so familiar with the surroundings, I started wondering if these visitors had long been coming through our yard on their way to others areas. Neighbouring gardens are rich with apple and pear trees, so there is every chance these lovely animals were not new to ours at all. It's far more likely they had been using our yard as a thoroughfare, possibly even going back years, long before we purchased the house just 14 months earlier. Whatever the situation may have been, the one thing I did know for certain was how wonderful an experience watching my new discoveries on video was, and I felt incredibly lucky and privileged to have the opportunity.

Now I just had to figure out how I was going to photograph them.

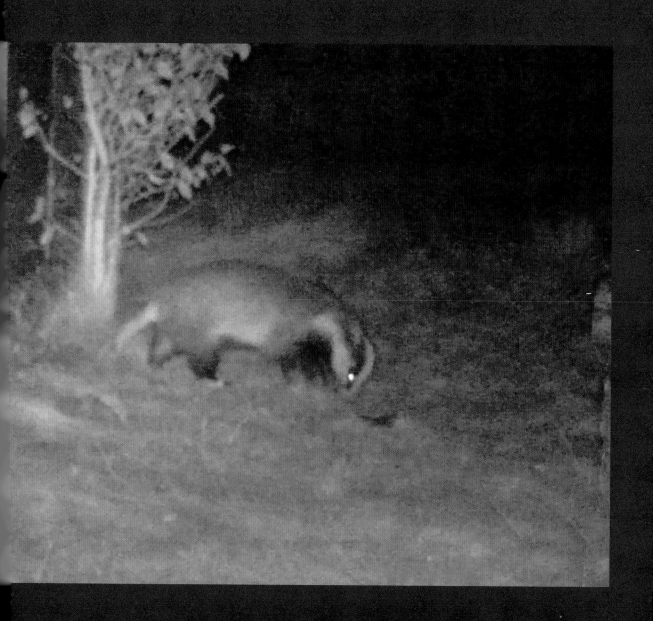

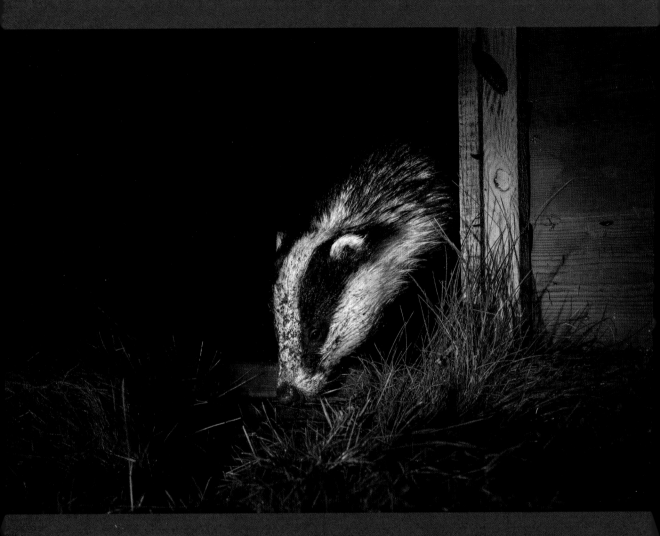

## BADGER DISTRIBUTION

The Eurasian badger featured in this book differs from
its American cousin in one key way: Eurasian badgers
live in family groups, not alone. They emerge from their
underground burrows, or setts, at dusk to play and
forage for food, which can be small animals such as
worms, rodents, frogs and insects, as well as bulbs,
seeds and berries.

# THE EXPERIMENTAL PHASE

**So there I was, faced with a couple of wary subjects visible only at night, which therefore required the camera to be triggered at distance and the subjects to be lit in the darkness. I had never used flash before in my wildlife photography, but this daunting prospect was the only option available to me.**

My opinion at the time was that flash photography was quite simply a quick way to ruin a photo. A large part of that rationale was due to the fact that I didn't really understand how to use flashes. If I'm honest, it all seemed just too technical and complicated, and therefore not worth doing. Consequently, I had dismissed the idea of using them many years before.

However, now that I was motivated to change my perceptions, my first plan of attack was to do some research on the principles of flash photography in general and not just for photographing wildlife. My reasoning was that if I could understand the basic theories of working with artificial light, I could then apply them to capture the images I wanted, rather than just trying to find out how to take wildlife photos using flash. This led me to the Strobist website, which features some very good articles on a variety of subjects for the beginner right up to the advanced

flash user. I spent a lot of time reading to gain basic knowledge of flash settings, using fill flash, controlling the direction and spread of light, and so on, before I even turned a flashgun on.

The one thing I did know beforehand was that, although I accepted the fact that flash would be used, I did not want my photos to look over-lit. It was very important to me that for most part, the images had to maintain a look and feel of the darkness. They needed to portray accurately the fact that these animals were visiting my yard after sunset.

▶ My desire to photograph one of the foxes in a wild looking environment certainly had a negative impact on the garden. However, once I knew there was a badger on the scene, my first plan of action was to drag the lawnmower out of retirement, and cut a strip of grass so that I could place the camera near the ground for a pleasing low perspective and unobstructed view.

Photography to me is about playing with the light. I love to do this with natural light so it seemed a waste to not get creative when I was soon to have full control of how my images would be lit.

## THE FIRST ATTEMPT

The first decision to make was how to connect my flash and camera. I knew on-camera flash was out of the question, so I investigated the two main options available to me: wired and wireless. It quickly became clear that each came with pros, cons and varying costs.

I launched myself into the world of wireless off-camera flash with Nikon's Creative Light System (CLS); as the single flashgun I owned at the time was compatible with this, no further equipment purchases were required. After some brief experimentation with how to get the flash and camera to talk to each other, I set about planning my first shoot.

My wife was immediately suspicious when she came home to discover me cutting the grass, without having been prompted. Given that I had spent months insisting the garden 'needed to look wild' for my fox photos, she was a little puzzled by my newfound enthusiasm for using the lawnmower. I quickly dampened her excitement by explaining I didn't plan to cut the entire lawn, rather just a strip leading up to the edge of the decking, where it met the corner of the shed. Crucially, this was just enough that, within the framing of the image I was trying to capture, the camera's perspective was unobstructed.

With the grass cut, my first setup was simple: mount the camera on a Really Right Stuff ball-head connected to the Skimmer Ground Pod, with the flash firing in from the right of the frame.

At this early stage, I triggered the camera manually using a remote release and, lacking a working security light, had to resort to leaving an LED flashlight balanced at the kitchen window, pointing out into the garden so that I could see what was happening outside. That first night at about 8 p.m. I sat at the table and waited. I knew from my recent trail camera observations that there was a good chance I'd get a visit between 9 p.m. and 11 p.m. and, as I had an early start the next day, I decided I would call it a night at 11 p.m. The previous night there had been two visits within that period. Having sat quietly with no sign of movement for two hours, I'd be lying if I said the appearance of a cat didn't initially get my excitement up before I realised what it was. False alarm aside, by 11:15. I was already beyond my self-imposed deadline.

However, with no visit yet and being incredibly eager to see the badger with my own eyes, I decided to hold out until midnight. It was a beautiful night, perfectly still with a crystal clear star-filled sky and to be honest, it was one of the first times since moving out of London I'd really appreciated just how peaceful our new surroundings were.

Midnight arrived and still nothing. However, as the badger had visited for the previous four nights running, I decided to wait a little longer still. At 1 a.m. I was faced with a decision: finally call it a night or wait for the next estimated arrival, which was then only half an hour away, at 1:30.

At 2 a.m. I was feeling quite tired, and by 2:15 I'd had enough. I could take no more; the badger had won this round. I switched off the torch, turned on the kitchen light and walked across the room to get the back door key. As I walked up to the doors, I switched the torch back on to venture outside. I could not believe it! The light shone out into the darkness as I reached for the door handle, and lit up the badger, who was sitting there, thankfully with her back to me, tucking into the peanuts. I hastily turned off the kitchen light

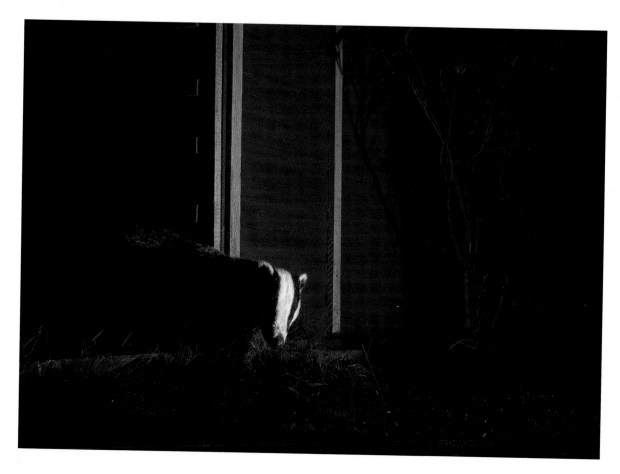

and grabbed my shutter release. I wasn't sure how the badger would react to the sound of the camera firing but wasn't entirely surprised when, at the first frame, she quickly retreated back down the side of the shed and into my neighbour's yard. I barely had time to worry if she'd return when I saw her head reappear out of the darkness. I waited for her to start eating again and took another shot. This time, the retreat was only a few feet. Again, she returned to the food and I fired another shot. This time, she stayed put but continued to glance at the camera after every shutter activation.

I took four more frames before deciding that would be enough for the badger's first encounter with this new noisy object. Once the badger had finished eating and wandered off, I waited for 15 minutes to ensure she was long gone before venturing out to collect the camera. To my dismay, I discovered it was covered in condensation. That was my first lesson, make sure the camera is always covered up. To be honest though, at that precise moment it barely registered, as my thoughts were locked into viewing the images I had just taken. They weren't perfect, but I had my first urban badger photo, with it peering out from the side of the shed. If I'm honest it was one of the most exhilarating photographic experiences I've had, and one I don't think I'll ever forget.

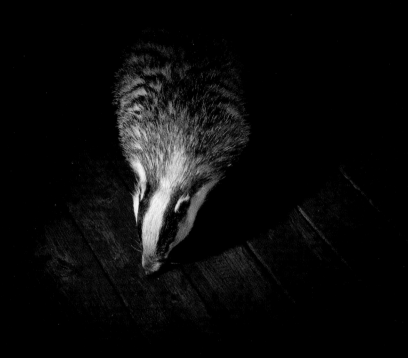

▲ **50mm, 1/250s, ƒ/11, ISO 200, SB-28 (x1), PocketWizard (x1), Nikon radio trigger.** Initially, I experimented only with light placement. I wasn't really trying to capture the badger in its surroundings, but more just to create interesting lighting scenarios with my single flash.

# THE INITIAL LIMITATIONS

Over the following days I experimented a little with different framing and light placement and quickly came to understand four things:

• The first was that the Nikon CLS system, although very good, was already becoming a limiting factor in my endeavours because it required a line of sight.

• Secondly, I really needed another flashgun to illuminate my images more evenly, and provide fill light to the shadows.

• Thirdly, it was important to start controlling the spread of light to create more drama in the images.

• Finally, I needed to invest in some form of flash stands or brackets, as the garden waste bin and bench, although handy, where certainly not the most flexible ways to get lights in position, and neither were the bricks I was using to hold them in place.

I admit I can be a little geeky when it comes to gadgets and camera gear, but in this case, knowing I needed another flash and some extra accessories but having almost zero knowledge of them, was an instant brick wall. Initially, I imagined I'd just buy a top-end flash. After all, it would have more up-to-date technology than the one I was already using, so would be the best one to buy, right? Of course, being top of the range, they don't come cheap s, so I didn't really want to spend a lot of money without doing a little research first.

Some digging on the internet led me to the brand Yongnuo, which sells what are essentially clones of Canon flashguns, but in Nikon-compatible versions. I didn't need any fancy metering, just the ability to set the flash power manually, so for a fraction of the price, I ordered one, and before I knew it, a parcel arrived at my door. Sadly, it proved not to be a smart purchase. I very quickly learned another important lesson when using artificial lights for this type of work: you must be able to disable standby on your chosen flashgun, so that it does not go to sleep. If the flash does go into sleep mode, the first shutter release only wakes it up and it doesn't fire until the second image, by which point the subject could already be gone.

The Yongnuo was returned, as turning off standby mode only delayed it for 90 minutes rather than disabling it fully, plus it drained the batteries at an alarming rate: a fully charged set was flattened in only six hours, even if no photo was taken. It was back to the drawing board and time for a little more research.

I consulted a couple of wildlife photographer friends who did flash photography to see what they recommended. They imparted the good news that most of the big-name manufacturers make flashguns which, when standby is turned off, will last 12 hours on a set of batteries. Fast power drain, it appears, only really becomes a problem with the cheaper manufacturers, which really shouldn't have come as a surprise.

What did surprise me, however, was that everyone I spoke to, even the Canon loyalists, all recommended a specific flashgun. Through these conversations I discovered that Nikon once made a flash that, even today, is regarded as one of the best available for this type of application: requiring only manual power adjustment and no metering information to be sent between the camera and the flash itself.

The flash in question was the Nikon SB-28. The problem? They stopped making them in 2004.

## THE EVER-GROWING KIT BAG

Once I knew what I needed, it was a case of buying one. Thus begun my close relationship with the auction site eBay. The SB-28 flash is, unsurprisingly, still a very sought-after item in the secondhand market, and I quickly discovered that many people joined the bidding on every auction. At the time I was shopping for one, most auctions were ending at prices up to £80 (around $100 at the time of writing). There were even a few Buy It Now examples at more than £100. I was lucky in that I stumbled across a new, boxed and unused one for less than half that. Combined with the flashgun I already owned, that was two flashes in the bag.

A few days later I spotted another one with little bidding activity: only a few hours to go and still under £30. I placed a bid just for fun, and the auction ended later that evening with me as the highest bidder at £38. I'd love to say I stopped there, but I became a little addicted to attempting to get good bargains. Over the

▲ An annoying quirk of the PocketWizard is one of practicality. The freedom they offer is superb, but without a solid connection to the flash other than via the required cable, I often became frustrated as they slipped down once everything was in place.

▼ For several years, I had owned but never used a flashgun, and I very quickly went all in. Thanks to eBay, my collection grew rapidly. The SB-28s were a relative bargain, but I knew my initial wireless setups would be be limited by how many PocketWizards, at around £130 ($165) for each one, I could use at once.

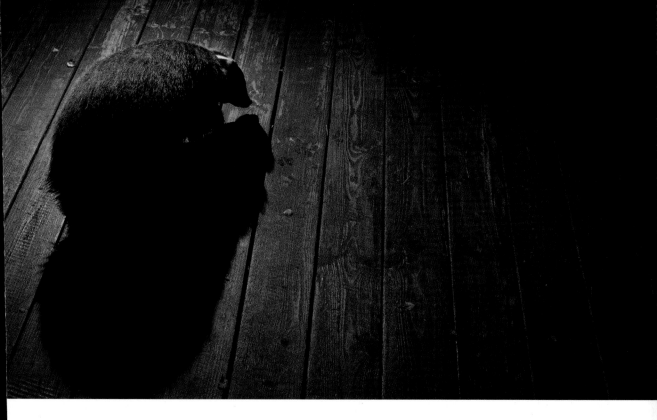

following eight weeks I just started bidding on any that looked well treated, in case I got them for a bargain price. Which is how I ended up with seven flashguns. But it's always good to have a spare. Or six.

During this time of frenzied eBay activity, I also invested in some Manfrotto Arms, Super Clamps and cold-shoe adapters so that I could improve the placement of my flashes. Next, I spent some time at a local craft shop, where I picked up some essentials in the form of cardboard and gaffer tape for some of the more DIY-customisations I had in mind.

My next buy was at the other end of the pricing spectrum, in the form of three PocketWizards. These are radio transmitters, one of which you attach to the camera and one on each flash; they allow complete freedom when it comes to placing your

▲ **50mm, 1/200s, ƒ/8, ISO 200, SB-28 (x1), PocketWizard (x1), Nikon radio trigger.** I particularly liked showing the decking. In combination with the light and shadows, it gave a wonderful texture to the photos, and provided a hint of the urban surroundings.

lights. PocketWizard offer several systems, with the cheapest at the time being the PLUS III. Because I could only use the old Nikon SB-28s in manual mode with no metering, the PocketWizards' limited ability to send only a command to fire the flash was of no concern. Nevertheless, even though they were one of the cheaper models the company makes, they were still a sizable investment for something I was only just starting to understand and experiment with.

However, I now had everything I needed to really tackle this developing project head-on.

# DEDICATION OR OBSESSION?

As the autumn nights began to lengthen, I pushed myself to master the art of taking photos at night. Because I triggered the camera manually, this was when the project begun to rule my life. My poor wife often came home from work to find the house in total darkness, and before she had a chance to step in the door, I'd shout through from the kitchen warning her not to turn any lights on. Understandably, the order was swiftly followed up by a well-deserved tut in my general direction.

It's fair to say I was becoming a little obsessed.

Almost every evening over the six weeks after that initial badger photo, I followed the same routine of sitting in the darkness waiting for something to come into the garden and walk within range of the camera, which I could then activate with my radio trigger. The hard part about manual triggering was working out when the fox or badger was in the optimal part of the frame. To help with this, I left objects on the ground just outside of the image area to indicate what could be seen through the camera. Then, when an animal arrived, I watched and waited, trying to time when to release the shutter perfectly. Most nights I'd stay awake until the early hours, alone in the silence, just staring out the window. There were even times I ate my dinner by the screen light of my phone, just so I could stay in the kitchen and keep an eye out for any activity that might unfold. Often, when I was up really late, I'd stream a film or TV show on my iPad, brightness turned to minimum, to keep myself entertained. I dread to think how many terrible films I watched at 3 a.m.

Those first months were certainly very slow, but as hides and blinds go, a fully heated one with full WiFi, bathroom and kitchen facilities, and only a 30-second walk from my bed, wasn't too bad and I think was a big part in helping me push through at times.

## FINDING THE PERFECT SYSTEM

I used the PocketWizard system for about six weeks, charging the batteries every day, but all the time thinking about how to take new images that required more than two flashguns. Adding extra lights into my existing wireless setup would required me to purchase additional PocketWizards. It was time to switch to a wired connection. As an added bonus, I could then make use of an SB-28 feature that wasn't possible with the PocketWizard. This function would allow me to drastically increase the battery life, while guaranteeing I would get a flash in the first frame of each photo, without having to leave the flash on constantly.

I first went down the route of PC Sync cables. They are far cheaper than the Through The Lens (TTL) variety and come in much longer lengths as standard. The additional cable length was welcome, as was the ability to use more than two flashguns if required. And so my new nightly routine became to stay up until the early hours, then go out into the yard and, by flashlight, untangle the wires I had tucked up and fed through things to keep everything in place. When bringing the gear inside, I missed the hassle-free nature of the PocketWizards, but given I was just feet from my warm house, the inconvenience wasn't exactly a deal breaker.

The downside of having the studio literally on my doorstep was that after a while it became draining. Unfortunately, the discovery of our garden visitors coincided with the onset of winter, meaning the pay-off for my efforts was incredibly low, as animal activity decreased. The situation was also, unsurprisingly, starting to irk my wife, who had almost forgotten what I looked like when not just a shadowy figure demanding darkness from the back of an already dark room.

I probably started to push my luck a little when I then began planning an excessively ambitious photo looking back towards the house. This made life around the house even more complicated, since it required different lights being left on in various rooms, depending on how I wanted the house to appear in the photo. Some days, I needed the kitchen light to be on; on others, the hallway light, and then sometimes the one on the landing upstairs. It wasn't even that straightforward, because if I wanted the bathroom light to look like it was on, I had to leave the landing light on, with the bathroom door open just enough to let some light in because if I left the bathroom light itself on, too much light would come from the window during a 30-second exposure. Eventually, I had pushed my luck too far, and after the first time I climbed out the bedroom window to place a flash on the roof of our extension, my rituals and requests were simply ignored.

▲ With a manual radio trigger as my only way to activate the camera, I spent many nights through the autumn sitting in the darkness waiting until the early hours of the morning. Sometimes the wait would pay off, but often, I would find myself going to bed without having fired the camera once.

Lighting needs aside, as the autumn days shortened, I needed to spend more time hidden away in the darkness. For the sake of peace, a compromise was made and each evening, rather than keeping a constant vigil, I sat in the living room being more sociable, and would only now and again go and look out of the back window. Predictably, this resulted in missed opportunities. On many occasions, I quickly popped to the kitchen to check if the peanuts were still in view and they were, but when I returned only a matter of minutes later to make a cup of tea, I'd discover they had gone.

With the activity slowing and my chances of capturing those moments now also reduced, I knew something had to change. My radio trigger had served me well, but it was now clear that a more automated process for triggering the camera at night was required if I was to successfully walk the tightrope of getting the project off the ground and also remain married.

## MOTION ACTIVATION

It was clear my next step was to buy some form of motion-activated triggering system. After some initial research, I settled on the best-known system of this type, which was the TrailMaster. This system is widely used by both researchers stationed in remote parts of the world and National Geographic photographers, who have for many years used it to photograph all kinds of wonderful images of animals, from tigers to snow leopards.

Through a lot of searching on the internet, it became apparent there are very few places to buy these in the UK. To be precise, there was one. Undeterred, I contacted the company direct, and sent a few questions to them in the USA about what I needed to achieve, before coming to a dead end when it transpired that they only shipped within the USA. I then found one on eBay, but sadly the asking price was too high for a unit that was very old and had seen better days. I was back to square one.

Luckily, fate was about to step in with a helping hand. One afternoon, I noticed a tweet from Will Burrard-Lucas, founder of Camtraptions.com and inventor of the BeetleCam, with an image taken using a motion sensor. I sent an email in response, and Will contacted me to say he was in the process of releasing a PIR motion sensor. He kindly offered to send me a prototype to test out, with a warning that although it might have had an extra hole or two drilled in it and there was no tripod mount, it was fully functioning.

A few days later the parcel arrived, and I excitedly unwrapped the box. The contents could mean the camera would be triggered by my garden visitors, which would open up a whole new world of photographic potential. It also signified something that some might argue was far more important: the return to a relatively normal home life.

I have, on more than one occasion since, referred to this wonderful little device as 'a wildlife photographer's social life in a box'.

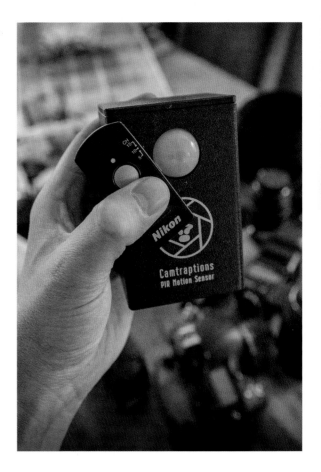

▲ Adding this little box to my stock of equipment and swapping it with the remote I had been using, was welcomed by all. These two units may cost roughly the same in money terms, but the freedom to break away from that little remote meant the motion sensor was worth so much more to me.

## EMBRACING FAILURE

I was very excited to set up my first official camera trap shoot. I opted to start easy and continue in the same way I'd been working: shining a spot of light down on the decking, which would light up a fox or badger as it crossed in front of the sensor.

I set everything up, framed the image, turned on the flashguns and PIR sensor and walked in front of it. The camera fired, signalling that the trap was complete. Well, almost. I placed some peanuts and decided the sensor was too far away, so I moved it a little closer. Everything was ready.

I went to bed but found it hard to sleep, in part because I was eager to see what was waiting for me on the camera the next morning, and in part because it was the first time I had left the camera outside all night. Of course, I knew it should be safe, as it was in my garden, but I still feared that some crazy freak of

▲ **50mm, 1/250, ƒ/11, ISO 100, wired SB-28 (x1), PocketWizard (x1), PIR sensor.** My first ever trap camera image was poorly exposed and far from successful. After framing the image, I decided to move the PIR sensor. I misjudged where the frame ended, so the fox can be seen sniffing the PIR sensor, which only adds to the humour of how badly this image failed.

weather might come through and wreck it, or that an unscrupulous person would decide to come into the yard and stumble across the free offerings left out for them.

On the plus side, the camera was still there the following morning. On the minus side, that was the only positive thing about the situation. Simply put, my plan had not gone to plan.

I was very excited to see what the night's activities had provided. Checking the back of the camera, it's fair to say I was a little disappointed and somewhat

annoyed with myself. Yes, the fox had turned up, but I had learned my first camera trap lesson.

**Never move anything after you've framed the shot, without double checking the composition.**

My first ever camera trap image (see page 75) showed the fox sniffing the PIR sensor, which I had inadvertently moved clearly into the frame. The peanuts I had placed out were similarly visible.

There's no denying that first image was a disaster. However, it's important to remember that the first time you attempt something you haven't tried before, it doesn't matter if it goes wrong. More often than not, it will, and this is good, because it gives you a starting point, a foundation on which to build, from which to learn what went wrong and then how to fix it.

Two nights later, I set up the trap again. This time I changed things a little and lowered the perspective of the camera so that the fox would be more head on. To counter this, I added a second flash on very low power to try to light it from both sides. This time, I also made sure the PIR sensor was placed outside of the frame and didn't move it once the camera was set. To encourage the fox to walk towards the lens, I placed a small handful of peanuts just behind it, in the hope this would entice the fox to approach head-on.

The next morning, I went to check on the camera. The excitement of the previous attempt had been replaced with a more subdued 'I hope it worked better this time' mentality. Checking the back of the camera, I was immediately over the moon to see a photo of the fox, walking in the direction of the camera (see page 78). What's more, it was actually licking its lips! A light rain shower in the night had also given the decking a lovely sheen on which the fox cast a reflection. It was

the only image captured that was worth keeping, but it was my first success.

Now that I was a self-proclaimed camera trapper, I really wanted to get the SB-28's unique standby feature working. It wasn't working with the PC-sync cords, and through further research and from conversations with others using these flashguns, I realised I needed TTL (through-the-lens) cables. I quickly discovered the downsides to these cables. Because of the electronics required for them to send the extra information between camera and flash, they are expensive. Also, they don't come in very long standard lengths: 3 metres (10 feet) is the longest standard cable before they need to be custom made. I learned you can get around this by adding further hubs on the bottom of each flash, which allows you to daisy-chain as many as you want together and place them farther apart. It wasn't elegant or flexible, but it would hopefully work.

We were going away for a couple of days, so I eagerly set the camera trap gain, using the new TTL cables. When I returned and looked through the photos, I could see that a few images had two flashes, but most only had one. Something still wasn't working as it should.

Through conversations with other photographers, I discovered some rewiring of the cables was needed, so a Canon-using friend offered to do the job for me as he had done his own. Sadly, the system still didn't work after that, and worse still, my flashes wouldn't go to sleep at all. We later discovered that the recognised rewire method didn't work for Nikon users, only Canon. Back to square one again.

There was another hurdle to overcome at this time. As the weather got colder and I regularly left the camera out all night, I found my front element would often gather condensation. I usually only discovered

this when looking at the photos the next morning and finding that they would be hazy and washed-out.

I spent all of that November and most of December experimenting with various methods of connecting my flashguns, practising with my placement of the PIR and trying to combat the condensation by covering cheap filters with various types of anti-fog sprays.

Add to that ever-declining visits from both the badger and fox to test my efforts on, and it's fair to say this was the lowest point of the project. I barely took three or four photos that were worth keeping throughout the whole of those two months.

On the bright side, thanks to that PIR sensor, it was at least liberating to no longer be confined to the kitchen on constant vigil. Had I still been doing that, on top of the rest of my failures and frustrations, it may have seen an early end to the project.

▲ **Flash connection trials (1), (2) and (3).** Initially I used PocketWizards (1). They offered positioning flexibility but were costly. Then I tried PC-sync cords (2). They were very cheap but only sent a fire command. Finally, (3), dedicated TTL cables. Expensive, short and less flexible when adding multiple lights, but they allow enhanced standby of the SB-28, if you can rewire them correctly. Which I couldn't.

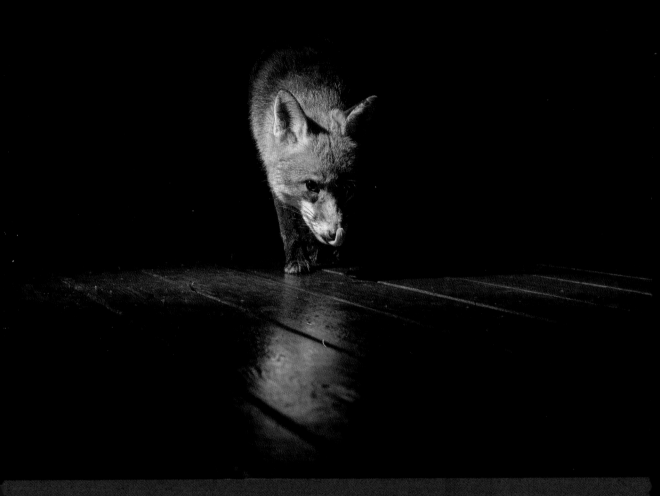

▲ **50mm, 1/250, ƒ/8, ISO 200, SB-28 (x2), PocketWizards (x2), PIR sensor.** My second attempt using the sensor was far more fruitful. An improved perspective, much better lighting, and the highlight of the fox licking its lips as it strolled through the frame made for a better photograph. A light shower also added a sheen in which the fox cast a slight reflection.

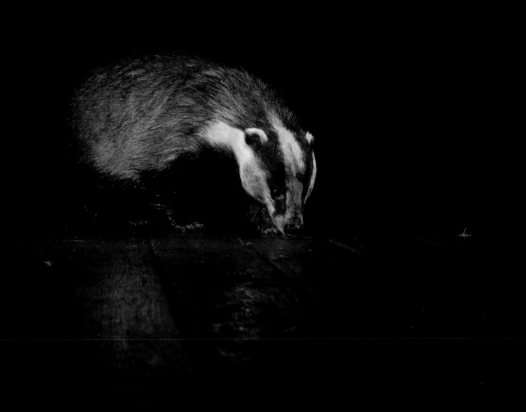

▲ **50mm, 1/250, ƒ/8, ISO 200, wired SB-28 (x2), PIR sensor.** Although my success rate for photos was very low during these initial experiments, I did get a few frames on camera that helped me learn and develop my knowledge. That learning process is never smooth sailing to begin with, so although frustrating at the time, I now have fond memories of those early months.

# AN EVOLVING PROCESS

**January 2015. The project was marooned in the middle of a photographic dry spell and I was feeling quite frustrated. I'd been working on it for six months now, and for four of those I'd had a clear objective in mind. Now, winter was in full swing, the wildlife had gone quiet, and my own limitations meant I was still not fully making the most of the visits that did occur.**

For a period, I also found myself creatively stumped. I think it's quite natural for photographers to go through this occasionally, and I was most certainly struggling for inspiration. Thankfully, I had booked a trip to Greece's Lake Kerkini, and I knew a change of scenery (and subject) would do me some good.

A few days into the New Year, I managed to finally secure a new photo of one of the foxes. In a burst of creativity, one of my more recent photo ideas had dictated where the Christmas tree should go. See from page 136 for more on how I captured my Christmas fox, shown opposite.

This proved to be a turning point. Before that it had been a slow burning project. The main source of my annoyance was the ongoing inability to get the SB-28's enhanced standby mode to work fully. I found it frustrating that Canon users could happily get the combination to work, whereas I, a Nikon user, could not. Another irritant was knowing that something could be done but not being able to do it. Thankfully, that was about to change.

## HARD-WIRING JOY

Again, Camtraptions came to my rescue, and provided a much-needed burst of enthusiasm. I posted about some of the technical issues I'd had using TTL cables on their Facebook group, and again Will reached out to tell me about a cabling system he had been playing with that he thought might solve my problem.

A few days later, a parcel arrived and I got my hands on the weirdly named Pixel Componor, a system that allows you to connect flashguns via network cables. A quick test confirmed it worked, and I was finally able to make my flashguns do what I had wanted them to for months: fire from sleep.

It's amazing how a small victory, which seems almost insignificant in the grand scheme of things, can give you a major boost.

This one most certainly came at a very good time. I may not have had an abundance of subjects visiting, but I could now leave my camera gear out undisturbed without the need to change flash batteries daily. With my weekend away to Greece, the timing was impeccable. A few days later, my camera bags were packed and another camera was set up in place for

an extended period. I was looking forward in equal measure to photographing something different for a few days, and seeing how the unattended camera would perform. I gave my wife some instructions on where to place a handful of peanuts out each night, and jetted off.

Upon my return to the UK, I eagerly checked the camera. Both the badger and fox had visited, but the images captured were not particularly interesting, which was probably a good thing because the peanut placement each night had been slap bang in the middle of the frame, rather than where requested. However, I had some amusing photos of my wife's tiny feet wearing my large boots as she walked back and forth in front of the camera. I also secured my first image of the neighbour's dog, who had snuck in through the bushes one evening.

The good news to take away from the weekend was that the badger had visited at least three times, and twice in one night. It was the first signal that things would soon take a rapid upturn.

▼ **30mm, 1 second, ƒ/8, ISO 400, wired SB-28 (x2), PIR sensor.** The first real breakthrough came just days into the new year. I had been trying to capture an image that would convey the festive season, and bring the human and animal worlds together. You can see the final successful image that this outtake led to in Chapter 6 (see page 134).

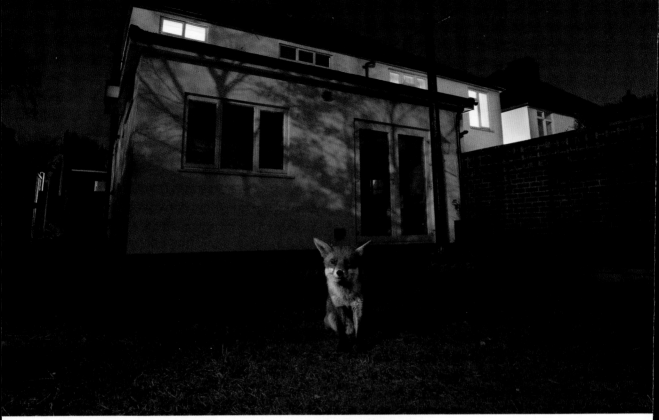

▲ **18mm, 30 seconds, ƒ/8, ISO 800, wired SB-28 (x2), PIR sensor.** In the new year, the fox visits began to slow. This image of one with the house lit by moonlight was one of the few I captured between February and March, before they all but stopped visiting the garden.

◀ On several occasions I turned my attention to capturing the badgers emerging from one of the holes in the bushes at the end of the yard. The setup for this was far from glamorous, but as long as the image comes together in front of the camera, it really doesn't matter what is going on behind it. Such is the luxury afforded by working at home.

## SPRING'S ACTIVITY SHIFT

During February and into March, there was a big shift in activity. Where I had seen only the foxes coming and going over winter, the badgers now slowly became active again. However, the fox visits slowly started to diminish.

The badgers, who by now would be feeding cubs, were thriving. As winter was replaced with spring, their regular visits really picked up. From one visit every couple of days, it went back to one a night, and then really went into overdrive: two or three visits every night. One particularly bad photo showed clearly that the visiting female was lactating, although I never saw a cub visit the garden. I did, on a couple of occasions, capture a photo with two badgers in the frame, which was very encouraging. I had always known there was more than one visitor as I'd seen the occasional trail camera clip early on, so it was lovely to see them both together on camera again after so long.

I also noted that where they had usually entered the yard from the side of my shed where it met the wall, they now far more frequently came through a hole in the bushes at the end of the yard. This was most notable because the hole grew in size almost daily. This led me to try and photograph the badgers as they entered through this leafy passage. I had spent a lot of time concentrating on showing the urban context in my images, so thought it might make a refreshing change to try to capture a few photos that had a more wild and natural look to them. I had to point the PIR sensor at the bushes, and bushes tend to blow around, which meant that I could only try for this image when there was little wind around. Even so, I ended up with a fair number of photos of branches swaying and not really doing much. Plus several photos of various neighbourhood cats.

As spring rolled on I noticed the badgers were unconcerned with how or where I left food for them. One night, I was lying inside on the rug in the dark at the back door when one arrived, sniffed around, ate up the treats on offer and then thoroughly investigated the entire yard. He then returned to the decking, walked right up to the back door, and proceeded to get up on his hind legs and scratch at the glass and door frame. Because I was lying on the floor, essentially underneath him, with just a window pane between us, I was quite definitely able to confirm it was the male! Needless to say, I never expected to get that intimate with a badger but then I guess that's wildlife for you. There's always a surprise in store somewhere along the line!

I'm still not sure even now what exactly caused him to get up on his hind legs and scratch at the door, but one theory is that because I must have used the handle after putting out food, maybe the scent made him want to investigate.

This curiosity to explore gave me an idea to try just for fun. Could I get the badger up onto the garden bench? It turned out I could. On the first attempt, a couple of peanuts placed on the arm was all it took to get him up there.

By contrast, the fox activity had essentially ceased. Between March and mid-July, I caught a fox on camera only twice, in stark contrast to the same time the year before when I was able to see regular visits.

▲ **35mm, 1/200, ƒ/8, ISO 200, wired SB-28 (x2), PIR
sensor.** The results of the setup shown on page 82 more
than made up for the way the equipment may have looked.
Obtaining this image required a lot of false triggers, due to
wind blowing the bushes about on some nights.

▲ **26mm, 1/200, ƒ/13, ISO 400, wired SB-28 (x2), PIR sensor.** With their nighttime activity in full swing, the badgers became completely unfazed by where food was placed for them. This enabled me to have a little fun on a couple of occasions, such as enticing them up onto the bench.

# THE ULTIMATE SELFIE

One of my more interesting ideas, as the weather warmed up, was trying to get myself in the photo with the badger. The idea was to make an image that shows how we can coexist with our wild neighbours, and I felt having a human form in the frame would achieve that.

I'd tried to get this shot once before, when I was firing the camera manually. Back then, I had to wait for the badger to appear, turn the flashlight off, turn the kitchen light on, sit in position, 'act natural' and fire the camera, all the while just hoping the badger was still there. It was a comical waste of time and I wasn't happy with the lighting.

This time, using the PIR sensor took away the guessing game of whether the badger was still there. Now, if the flashes stopped firing it would be pretty obvious. So, one evening when my wife was out, I dedicated the night to sitting out in the dark, much like I used to. I had placed my laptop at such an angle that once at the table, its screen would be visible, but I would not be recognisable. I sat and waited. Just after 9 p.m. I had my first visit. Once the badger came close to the house, I turned the security light off and the kitchen light on. Quickly, I seated myself in position and remained still. The exposure needed only 1/5 second, but I didn't want to be blurred. After about three minutes and seven or eight flashes, everything went quiet. I looked at the back door only for the camera to go off again. That was the final frame before everything went quiet.

▼ **35mm, 1/5, ƒ/10, ISO 800, wired SB-28 (x3), PIR sensor.** I had a desire to add a real human element, and wanted to take an image that shows how we can (and, unknown to many, no doubt do) coexist in peace with our wild neighbours.

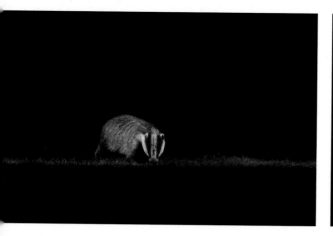

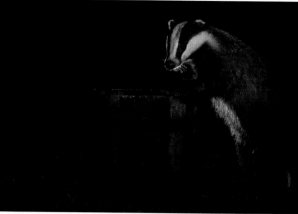

I waited a few minutes then went out to see if I'd had any success. That final frame, in which I was looking at the back door, was quite amusing. By chance, both the badger and I were looking straight into the camera. It was very comical, but caught off-guard, my face looked a little angry, which was not the message I was trying to convey! Luckily another of the frames worked as intended, with both me and the badger looking busy, going about our lives, seemingly unaware of each other's existence.

## GOING BACK TO WIRELESS

By that summer, the project was finally coming into its own. My understanding of the techniques I was using had been improving by the day, and the badgers had been very active, save for a quiet spell around May and June. It was also around this time I decided to go back to a wireless setup. This was not because I had any issues, per se, in working with the Pixel flash hub, but I was growing a little tired of having to drape cables all over the garden and come up with increasingly elaborate ways to get them tucked into positions where they were not causing a trip hazard. I think the final straw came with a shot that required me to tape a 30-metre (100-foot) cable up the side of the house.

Added to that, my ideas for photos were becoming a little more complex and, for some of them, cable

▲ **50mm, 1/250, ƒ/11, ISO 400, wireless SB-28 (x3), PIR sensor.** With no cables to limit flashgun placement, it was now far easier to put them in locations that might otherwise be an issue, such as here, creating backlight to the scene.

placement was the limiting factor. It will come as no surprise to you when I say it was Camtraptions who again came up with a solution for me. They had seen the need for a camera-trap wireless-flash solution too, and thankfully came up with one that also allowed for the SB-28 to work with its special standby mode.

With that, I promptly added a set of their wireless triggers to my kit bag. It did mean going back to working with more batteries and the charging issues that come with that, but I'd forgotten just how refreshing it was to have the freedom of flash placement that I used to enjoy with the PocketWizards. Even better, the Camtraptions wireless triggers were much cheaper than the PocketWizards, and they had a hot-shoe mount, meaning the flash would attach directly to them, which made placement far easier. I've come to the conclusion that when working at home, a wireless flash solution is by far the best. If leaving a camera out in the wild, the battery issue would be a deal-breaker but for the ease in which you can quickly move flashguns about in the home environment, it's an obvious choice.

## WHAT'S NEXT?

As autumn started to roll in, I looked back on my first full year of photographing my nocturnal visitors. It had been a roller coaster of a year! I went from having no interest in the garden, to discovering I share it with some incredible animals. I learned an entirely new photographic technique and I wrote an ebook about the experience, which has evolved into this book.

I was still working on new images and there were photos I had taken over the previous year that I felt I could improve, to take them to the next level. The beauty of working at home meant I could continue to push myself while also working on other endeavours away from home.

It had not all been smooth sailing. Two of the biggest problems I faced, technical issues aside, were subject activity and inspiration. Because I began the journey the previous autumn, dwindling animal visits and my own lack of know-how made it a real slow burn and it wasn't until spring 2015 that I was really able to push ahead.

Inspiration is always tricky. I think photographers all get the equivalent of writer's block from time to time, and I certainly experienced it while taking this portfolio of images. I didn't want to just take the 'same' photo over and over but wanted to throw something different into the mix to produce a little more creativity. There were certainly times when I stared out the window and drew a blank. When those days arrive, I set the camera up in any position, even one that seems doomed to failure, and just see what happens. Often, through trial and error, something going wrong gives me the idea for something new.

Of course the real stars of this particular show for me continue to be the badgers. It's a privilege to be able to observe these wonderful creatures so frequently, and despite reading some horror stories, they haven't dug up my garden. In fact, other than the photos I've captured, you would never know these animals had visited.

Before we move to the next part of the book about the technical aspects of this project, I can tell you that in that late summer and early autumn, three badgers turned up together on several nights, so I can't help but wonder how many more I might see given time...

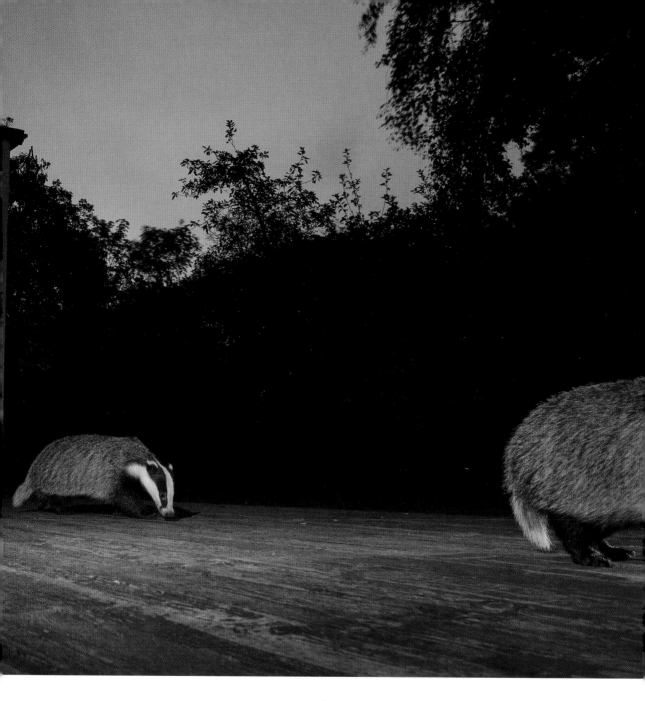

▲ It was an incredible year and one of my most photographically accomplished yet. The badger activity showed no sign of stopping, other than during their naturally less - periods, so I was optimistic that the months to come would provide good opportunities. I was determined to catch these three fully on camera before long.

CHAPTER THREE

# ADVANCED TECHNIQUES

**The art of artificial light, and revelations about remote camera triggering**

# UNDERSTANDING BASIC FLASH EXPOSURE

When working with flash, it is vital to understand the way in which the light from the flash is controlled by the settings on the camera. When shooting a scene with ambient light only, you can control the exposure of everything within the frame by changing the shutter speed, aperture and ISO.

Introducing a flashgun, however, fundamentally changes the way the image is exposed.

## SHUTTER SPEED DOES NOT AFFECT FLASH EXPOSURE

The burst of light from the flash is faster than the shutter speed of the camera. This means that when flash is introduced, the shutter speed only helps to control the ambient light and has no relevance to the exposure of the flash.

Consequently, you need to adjust flash output power to work with your required aperture and ISO settings. These will still have an impact on the ambient light exposure, but once they are set, you can adjust the shutter speed to compensate for any changes to the ambient light levels you require without it having any effect on the flash exposure. In other words, set your camera exposure based on how you want the ambient light to look, then set your flash power to the desired level to balance that ambient light.

That said, I'm an advocate of not setting flash power too high.

It's important to understand how to increase the exposure of dark scenes without necessarily increasing the flash power itself. I usually set the flash at 1/8 power as a maximum, unless it is placed very far away. If more light is needed, I increase the ISO or open up the aperture to make the camera more sensitive to light, rather than increase the power output.

## MANUAL OR METERED?

You can use modern flashes in TTL (through-the-lens) mode, whereby the camera suggests the flash power, based on the camera's meter readings, but I highly recommend you learn how to set flash manually. It's much the same as setting exposure in camera. You can use a semi-auto mode, but to really get the best from it,

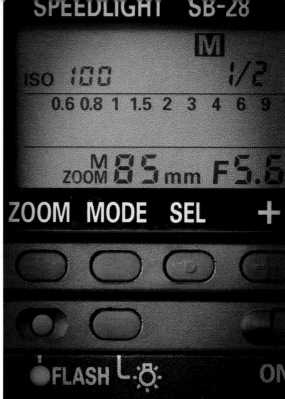

you want to be in control of the camera and flash, rather than relying on the camera to make an educated guess.

While using TTL metering has the advantage of helping to automatically balance flash output with ambient light, when working in complete darkness, it isn't clever enough to understand the subtle ways you may want to light the scene. An additional advantage of working in manual is that you can use any flash you have on hand.

## CONTROLLING LIGHT SPREAD

As well as understanding how flash exposure works, the other important factor to account for, and one that can make a substantial difference, is controlling the spread of light. Simply letting the flash throw light out as far and wide as it can go won't always get the best results. It would be a shame not to make the most of the creativity that having full control over where and how the light illuminates allows.

Most flashguns, even the simplest, have a zoom feature, which you can use to concentrate the light that is emitted. This can be further enhanced, or if you have a very basic flash with no zoom, by using snoots and shades to better sculpt the light and control where it does and does not illuminate.

You can make these yourself as they do not have to be fancy, as long as they allow you to have some degree of control over the light spread. I made mine using sheets of cardboard, which I covered in black waterproof tape, then simply rolled into a tube and attached to the flash using Velcro™ – all very simple, and the materials were inexpensive.

▲ Remember to set the flash zoom to maximum (85mm in this case) if you are using a snoot. Snoots are simple, cheap and helpful, and a great way to control the spread of flash if the zoom mode isn't effective enough, or you are using a very old flash without that functionality. It's worth making several at once, as they fall apart over time.

## ADJUSTING POWER FOR THE ZOOM

One important tip to bear in mind: if using a snoot, make sure the flash zoom is set to its maximum, for example 85mm. Otherwise, you will need to increase the output from the flash to increase the exposure from the light. The wider the field of view the flash is illuminating, the more power will be required to light the scene farther into the distance. The reach of light for any given power setting is going to be farther when zoomed in. Because more concentrated light doesn't need to be as powerful, this is another technique to use for keeping output from the flash low.

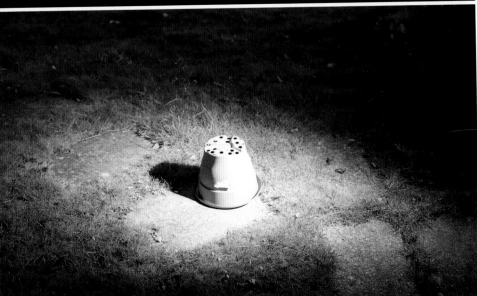

◀ These three images, all taken with the flash set to only 1/32 of full power, with a shutter speed of 1/250 second, demonstrate how you can use very low flash levels but compensate for the illumination required for your subject using aperture and ISO rather than higher flash power.
Top: ISO 64, *f*/8.
Middle: ISO 200, *f*/5.6.
Bottom: ISO 800, *f*/4.

# CONNECTIVITY SIMPLIFIED

**Among the biggest challenges when you start out with flash is working out what units to buy and how to connect them to get the most flexibility.**

You can choose between feature-heavy units, some of which now have built-in radio triggering functionality, or you can go cheap and cheerful. Crucially, whatever you decide, my best advice is to make sure the flash you buy can do the following two things:
- **Disable Standby.** You need to be able to do this so the flash does not fall asleep. If it does, you have to wait for it to wake up and charge before it will fire, which could mean you miss the shot.
- **Stay Awake for 12 hours.** With standby disabled, the flash needs to be able to make a set of batteries last for at least 12 hours, so that you know you won't run out of power at a crucial moment, especially if it's been on for an extended period.

Ensuring your flash has these two features also means the units will be more applicable in camera-trap solutions, should you later decide to go down the same route that I followed. The Nikon SB-28 that I use meets the above criteria, making it the model I would recommend, regardless of whether you are a Nikon user or not. In addition, the SB-28 offers a very special

function that no other flash currently on the market offers, despite being more than 10 years old. What exactly is it that makes camera trappers the world over, even Canon users, want to use this very old Nikon flashgun for their artificial light needs?

Traditionally, flashguns work by constantly monitoring and topping up the capacitor; you can hear the faint high-pitched whine they make when doing so. This is done to ensure the flash is ready to fire when the camera takes a shot. The disadvantage to this permanent state of readiness is that the batteries run out after anywhere between 6 and 18 hours depending on the flashgun and battery type used.

Naturally, you can put your flash into standby mode to conserve power so that it stops topping up the capacitor and goes to sleep. However, when this happens, the first frame the camera takes only wakes the flash up. The batteries then quickly charge up the capacitor and the second frame then fires the flashgun as required. This is not the whole story for the SB-28, as I'll explain on the following page...

## FIRE-FROM-SLEEP CAPABILITY

The SB-28 is unique in that it contains a very slow-drain capacitor. Because of this, when it goes into standby mode, it retains its charge for a vastly greater period of time. The icing on the cake is that when connected to a compatible flash trigger, the SB-28 will 'fire from sleep', waking itself with the first shutter activation, even if it's been asleep for several days. The advantage of this is two-fold:

**1** There is always a flash in the first frame. Without fire-from-sleep, you'll just get a single black image; by the time the first exposure is finished and the flash is ready for the second, the subject will be gone.

**2** Because the SB-28 goes to sleep when not in use, the combination of a slow-drain capacitor and fire-from-sleep give the benefit of long battery life.

To put the battery life in perspective, if you leave the SB-28 on continuously, the power lasts for around 18–20 hours, even if it doesn't fire. Compare that to using it in standby mode, where it shuts down but fires from sleep, a single set of AA batteries can last for several weeks – depending also on camera trap activity and flash power output, of course.

**NOTE:** The slightly updated SB-28DX does not work the same way as the SB-28. So if fire-from-sleep and prolonged use of flash batteries are required, you must choose the older model.

▲ ▶ The Pixel Componor allows fast, easy connection of three flashguns. The unit itself comprises an On/Off switch for each of the inputs, plus a fourth switch on the back labelled A/B/C. This allows you to assign which of the three connected flashguns will receive a TTL signal from the camera, should you have a compatible flash and require that functionality.

## MAKING IT WORK

That's the good news, but as I discovered, there are some caveats to harnessing this feature because this functionality doesn't work straight out of the box, even if you're using a Nikon DSLR.

To get fire-from-sleep working on the connectivity side, there was much initial trial and error. At the time of my research, I could not find any Nikon users who operated this setup – all the SB-28-using camera-trappers were shooting with Canon bodies.

I'll spare you too much detail of the complex, excessively technical and money-wasting methods and experiments I went through involving rewiring and the purchase of a variety of different cables, splitters, hot-shoe accessories, and so on. Finally, I discovered a very simple solution that takes away all the stress of working with fire-from-sleep.

## THE PIXEL COMPONOR

The name may be a little quirky, but what this clever little box of tricks does is essential for anyone who wants to use a wired flash-triggering solution. The kit provides you with a hub that sits on your camera hot-shoe, much like the more traditional PC-sync cords and brand-specific TTL cables traditionally used to hard-wire flashes. Another attaches to the flash.

However the Pixel Componor uses RJ45, better know as ethernet or network cables.

There are several reasons why this is a far better alternative to messing around with older PC-sync and dedicated TTL cables:

- RJ45 cables are very cheap.
- They are available off the shelf in a variety of lengths, from under a metre (3 feet) to longer than 50 metres (approximately 160 feet).
- They support TTL metering with compatible flashguns.
- And, crucially to me, they are compatible with the SB-28 fire-from-sleep feature.

There are two downsides to this setup. The first, that firing more than three flashguns at once becomes tricky, requiring RJ45 splitter hubs and daisy-chaining flashes together.

The second, while they support the SB-28 fire-from-sleep without needing rewiring, this only applies in a Nikon-to-Nikon setup. If you use Canon DSLRs, although they will fire the SB-28, they will not do so from sleep, even if you buy the Canon-compatible hub. Instead, they will only wake the SB-28 on shot one, and fire on shot two.

To solve the compatibility problem, there is now also a wireless plug-and-play solution that lets the SB-28 work its magic, independent of being connected to a Nikon or Canon camera.

## CAMTRAPTIONS WIRELESS TRIGGERS

The wired method using the Pixel Componor was my main system for connecting flashguns for quite some time, however there were (and still are) times when having to trail wires all over the yard was a hassle. One particular shot setup that required 30 metres (100 feet) of cable gaffer-taped up the side of the house to get the flash in position would have been far easier had these triggers been available.

As with the Pixel Componor wired method, there are several key benefits of the Camtraptions Wireless triggers, and one fairly obvious downside to them:

- They are inexpensive compared to equipment like the PocketWizards.
- They can work as a remote camera trigger as well as a flash trigger.
- They are compatible with the SB-28 fire-from-sleep feature.
- They allow a mix-and-match of Nikon / Canon DSLR and flashguns.
- An unlimited number of flashguns can be triggered with ease.
- The downside: they require batteries.

To allow these triggers to fire a Nikon flash with a Canon body, cleverly the hot-shoe connections have both Nikon and Canon contacts, making them cross-compatible with each other's flashguns. That means that if you're a Canon user and want to delve into the world of camera trapping, you can make full use of the Nikon SB-28 and its fire-from-sleep feature just by buying a set of these cheap wireless triggers. No more rewiring and limitations due to flash position being restricted by the length of the cable.

As mentioned above, these wireless triggers can be used as a remote camera release, by attaching one of the receivers to your camera's hot-shoe, then connecting that to your camera's shutter release cable input through the supplied cable.

Alternatively, they also work in conjunction with the Pixel Componor, meaning you can use both wired and wireless flashes together, should you need to. In that setup, you can plug the wireless transmitter into the hot-shoe, then plug the Pixel in to that. This results in an amazingly flexible combination of flash connection, all with the ability to still use the SB-28 in fire-from-sleep mode.

## NIKON CLS

If you shoot Nikon and have compatible equipment, it's certainly worth playing with CLS and Commander Mode, just to become familiar with the basic workings of remote flash. It works by using your DSLR's pop-up flash to send a signal to a compatible flashgun, telling it to fire when you take a photo.

One of the great things about CLS is that you can control the exposure of the flash output from the camera itself, by dialling in plus and minus exposure compensation. This means you can take test shots, quickly review these and adjust output on the spot, if required. It may not seem like much effort to walk over to the flash and adjust its power yourself, but it is handy to be able to do so on-camera and makes quick work of getting the lighting right, especially if you have placed the flash in a hard-to-reach location.

Potential problems are that in order for the camera to send the trigger signal, a line of sight is required between the on-camera pop-up flash and the receiver on the off-camera flash. In addition, the pop-up fires a low-power burst of light, which may be undesirable if it lights up a part of the image that you do not want lit, or if it creates an extra catchlight in the subject's eye.

## RUNNERS UP

The other methods for both wireless and hardwiring flash, touched on in Chapter Two, are not really worth the effort. Given the extra costs and fiddly processes involved, the payoff simply isn't worth the time and money invested. Now that there are simple plug-and-play solutions available, inexpensive ones at that, the equipment described here is what I would recommend to anyone wishing to jump into flash work.

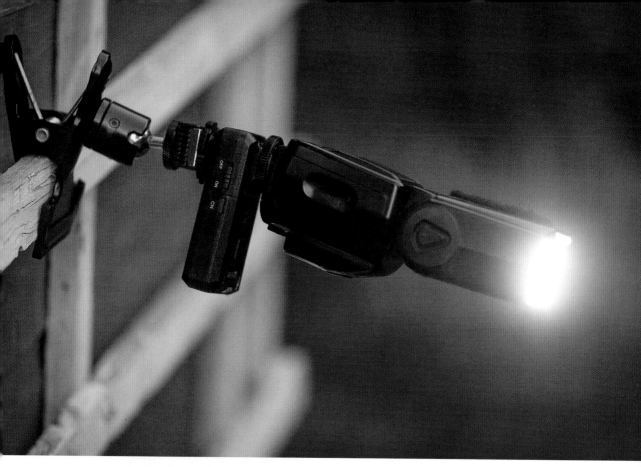

▼▲ With the Camtraptions wireless triggers, you place the transmitter on the camera hot-shoe and a receiver on each flash you wish to fire. Because the receivers attach directly to the flash, it makes it very simple to position the two. In the combination shown above, I've also used a cold-shoe adapter to mount the setup to a clamp, so that placement on my shed is quick and easy.

# TO FLASH OR NOT TO FLASH

**The technicalities of using flash in this application should also encourage deliberation about whether to use it at all. The use of flash in wildlife photography is hotly debated. Many photographers refuse outright to accept it as an ethical way of photographing wildlife. They argue that it harms or causes distress to the subject, who could potentially be momentarily blinded when the flash goes off, in the same was as humans are when a camera flash goes off in the dark.**

This question was an initial point of internal debate, something that I wanted to explore early on and gave great thought to. Although it's a technique that has been practised for many years the world over, I still needed to satisfy myself that I could pursue it with this project. Despite having seen many images of the same subjects photographed at night, because every situation is different, I chose to do some testing and observation before coming to any conclusions.

In the early days, I watched both the fox and badger to see how they would react when the camera was first introduced. I decided that if they showed any sign of distress from the flash, such as flinching or acting dazed, I would stop. Plain and simple.

Those observations revealed that both animals reacted only to the sound of the camera shutter going off. Initially, that sound was enough to send them running from the garden, only to return a few minutes later. I had suspected this would be the case as there is little noise at night, and the shutter noise would be quite alien to them.

Next, I tried removing the sound of the camera from the equation. I performed a couple of tests where I fired the camera from inside the house, using PocketWizards to trigger the flashguns remotely.

I noted that when the sound of the camera was removed, neither animal reacted when the camera fired and the flashguns went off. There was no similar reaction to the human response when flashed by a camera in the dark. No flinch, no lift of the head to look at the source of light, no discernible change in behaviour, no running away. Essentially, they continued as if nothing had happened.

Once the camera was placed back outside and the shutter activated, it drew attention again and on the first or second release, they would sometimes run or walk away. It was very clear that although the lights appeared to be of no concern, in the dead of night, sound was clearly an issue. I also noted that there was more of a reaction when the camera was placed on the decking, when compared to it on the lawn. With the camera on the hard wood, the sound and vibration of

◀ The Camtraptions wireless triggers allow for an unlimited number of flashguns to be connected with ease. However, they do also work in conjunction with the Pixel Componor. Here, the Pixel hub is connected to the wireless transmitter. This will allow any hard-wired flashes to fire at the same time as any wireless ones, which is useful if battery power is of concern.

◀ This off-putting photo shows a selection of some of the equipment I collected and experimented with before arriving at the simpler solutions discussed in this section. Pictured are three different types of flash cables, four different types of adapters to connect flashguns and four different ways to trigger the camera itself. I can report that most are now not needed.

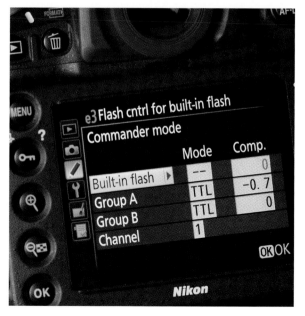

◀ Nikon's wireless flash system, on more modern DSLRs, allows you to control the output power of the flash directly from the back of the camera. This feature is useful, as it allows for faster setting up and balancing of remotely placed flashguns.

the shutter and mirror mechanism was emphasised, even to my own ears.

I then tried to muffle the sound of the camera by placing it inside a Wildlife Watching Supplies PVC waterproof cover, with a T-shirt stuffed inside. This still caused the animals to glance in the direction of the camera, but dampened the sound enough that it eventually stopped either animal running away, although the fox seemed to take a little longer to acclimatise than the badger. Of course, it is possible that their tolerance to the noise was growing, and had nothing to do with my sound-proofing efforts.

I always like to err on the side of caution, so I think that even in a photographic situation where everything seems fine, it still makes sense to be as careful as possible. As such, my methods for using flash are based around the following:

- **Power.** I never set my lights to full power. If more brightness is required, I use the aperture and ISO to increase the sensor's sensitivity to the flash output, as discussed in Section 1 of this chapter, 'Understanding Basic Flash Exposure' (see page 92).
- **Position.** In most situations, I place my flashguns at relative distance, up well above the subject's head height, looking back down towards them.
- **Direction.** I generally angle the flashes in from the extreme sides of the subject, so they're on the periphery, or ensure there is never more than one light being picked up per subject's eye. This also has the visual appeal of not giving multiple catchlights, which can become a distracting element to the image.
- **Duration.** The camera fires only one image at a time. Depending on the desired exposure settings, there is a minimum duration of 4 seconds and maximum of 30 seconds between each frame and flash firing. Added to this, because the camera only triggers when the animals walk past it, on some nights only one frame was taken per visit, and at most four or five.

## IMPORTANCE OF TESTING

Practise your flash exposure on inanimate objects before doing so on anything wild. I have taken many photos of my garden plant pots doing just that (see page 94, for instance).

While I appreciate that my findings and methods may not convince those fully against the use of flash to change their opinions (and all credit to them for sticking to their principles), I believe that photographic practices are subject-, situation- and implementation-based. I feel, as has been the case with those using it many years before me, there is responsible and irresponsible flash work.

To reiterate, I have never seen any signs of distress shown when the flashguns have fired. The badgers especially just continue to sniff around the garden or eat the treats laid out, without so much as a pause for thought. Even if they come when there is no food, they forage without reaction. Had that not been the case, I would have stopped immediately. As, I believe, should others.

On the contrary, at the time of writing, they have been returning for more than a year. Not only have they continued *not* to react to the flashguns, but the camera itself has long since become commonplace and they've learned that the sound it makes will do them no harm.

However, the badgers have, on more than one occasion, left a rather large nose print on my front element caused by an over-exuberant sniff of the camera as they go about their nightly rounds.

# MOTION SENSORS & TRIGGERS

**There are traditionally three ways to fire the shutter on your camera. You can press the shutter button yourself, use a manual trigger to fire it from a distance or, if you're feeling adventurous, use a trigger that fires when motion is detected, such as when the subject breaks a beam or similar. This is a camera trap.**

There is a time and place for all of these methods, and which one you need to use will in part be based on the subject, where it is and when it appears.

When I started this project, the idea of camera trapping sounded unnecessarily complex, designed for either pioneering *National Geographic* photographers or researchers monitoring rare and elusive animals deep in a jungle somewhere. I certainly didn't think it was something designed for use at home. However, in recent times there has been quite a surge in use of this technique, and some beautiful camera trap images are being produced, both in the UK and elsewhere.

Let this inspire you, rather than allow this initial relative complexity put you off. As you'll see in Chapter 4 (see page 112), once you have some basic knowledge setting one up is a simple process. That doesn't mean camera trapping itself immediately becomes easy, rather that the basic principles behind setting them up isn't as daunting as it first appears. Putting that knowledge into practice will certainly test your creativity, as you have to previsualise your shot and take into account factors such as the framing, where the animal will appear, and what the weather is likely to be, so that you can anticipate what the elements will throw at your equipment while it is unattended. That's before you even consider presetting the exposure for what the light will be like during both day and night.

Easy? No. Frustrating? Yes. Rewarding? Definitely!

## MOTION SENSORS

These are used to photograph subjects that are either typically very shy or are in difficult or hard-to-reach locations. The theory is simple, but there are several types of triggers available, depending on what you want to achieve.

My research led me to two of the more popular options, namely the TrailMaster and the Wildlife Watching Supplies Infrared Trip-Light Beam. Both of these come as two units: a transmitter and a receiver. The transmitter sends a beam to the receiver, and if something breaks that beam, the camera shutter is activated. Both are highly capable solutions, are fairly costly and are quite complex to set up. To further intimidate those new to trapping, the TrailMaster is available in three different variants.

These triggers can be complicated and very technical in their setup and execution, especially the Trail Master, which is famously used by *National Geographic*. If they seem too daunting, there are other options and solutions out there which are less complex and more user-friendly.

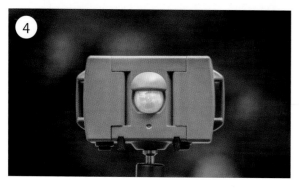

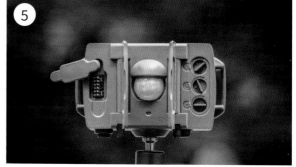

1 During the initial stage of this project, I used the original MKI Camtraptions PIR sensor, with its slightly non-user-friendly control system. Since then, I have upgraded to the more user-friendly MKII and MKIII units seen in the pictures here. The two later versions feature the same green, hinge-door design, but the MKIII sensor can also be wirelessly connected to the camera.

2 The underside of the Camtraptions PIR sensor features three very simple functions: the jack to attach the cable between it and your camera, an On/Off switch and a threaded tripod mount (obscured here by the mini ballhead). The simplicity of this plug-and-play approach makes it easy to get the sensor going straight out the box.

3 With the back unscrewed, the battery compartment presents itself. I have favoured the Eneloop rechargeable batteries, which power the unit for around 10–14 days. However, disposable alkaline batteries will provide constant power for up to a month.

4 Here, you see the front of the sensor unit with its swing doors closed, showing just the sensor itself. It has a small, unobtrusive hood over the top, which helps reduce false triggers from objects above the sensor, like tree branches blowing in the wind.

5 On the newer MKII sensor, all the controls are accessed via two hinges on the front of the unit, which also act as blinds to adjust the detection area of the sensor itself. With the controls so accessible, it is easy to set timings and sensitivity – fine-tuning how the sensor reacts to movement, the trigger time and ambient light conditions.

# PIR MOTION SENSORS

PIR sensors differ from traps in that they consist of only a single unit with some very basic controls, unlike the traps described on the previous page, which require two units: a transmitter and a receiver between which the beam is sent. I favour the more simple PIR approach, as the PIR sensor does not need many of the settings required for the more advanced beam-based units. There is also no need to place both a transmitter and receiver out, ensuring that they can see each other, and figuring out how to power them.

While someone with a good knowledge of electronics could buy an off-the-shelf sensor and circuit board and construct a homemade triggering system, I was more than happy to buy a ready-made unit in the form of the Camtraptions PIR sensor.

After I was given a prototype unit to test (see page 74), I was so impressed with it, I bought a second one when they were officially released, and then replaced one of those with the second-generation unit, when they were launched still later. (A third-generation is now available.)

The unit is simple in its design. The sensor is at the front and there is a power switch and input jack underneath. Connect it to your camera, switch it on, and when something walks in front of the sensor your camera will take a picture. It doesn't really get simpler than that. The second-generation unit has some settings on the front of the housing, which can be tweaked. The dials allow you to adjust how sensitive the sensor is to movement, for how long the trigger will send a signal to the camera telling it to fire and finally whether you want the sensor to work both day and night, or at night only. In addition, opening the back provides access to the cradle that holds the six AA batteries required.

The connection to the unit is a simple 2.5mm jack, so extension cables are cheap. This allows for great placement flexibility as you can put the sensor some distance from the camera if needed.

# CONS OF THE PIR SENSOR

Although easier to set up and use, PIR sensors are not without their quirks to work around in order to get the very best from them. As with most things, a little bit of knowledge and forethought helps.

● **Detection Zone.** Because PIR sensors are generally used in applications that require activation of something quickly, such as security lights or house alarms, the detection zone is huge. For example, in its standard form, the Camtraptions sensor will fire the camera if you step anywhere in front of the sensor, on an almost 180 degree arc. As you can imagine, this ultra-wide field of view may not work in every situation, as depending on the focal length of the lens, the camera may start firing before the subject is even in the frame. There are times that this may be of use where you need to detect your subject early to counter the slight delay time in the sensor registering movement, such as an animal running at speed or flying through the frame. However, in everyday use, it does need to be accounted for.

Addressing this wide field of view is simple. On the older unit, you could cover the front of the sensor with a hood, to narrow down the field of view of the detection zone, in extreme cases, almost turning it into a single beam that can be targeted more accurately. I've made hoods out of cardboard, tape and plastic bottle tops. Nothing fancy is required as long as it gives more specific direction to the detection zone. It's not as precise as a break-beam trigger, but it's certainly a close second. On the second generation sensor with the green outer housing, you can use the front flaps to alter the spread of the detection zone.

● **False Camera Triggers.** This is possibly the main issue that makes these types of sensor a little awkward to use from time to time, and is where the sensitivity setting comes into play. Adjusting that, in combination with using a snoot to reduce the detection zone, false triggers can be substantially reduced. I still get them sometimes if it's windy or there are drastic changes in

▲ Regardless the PIR sensor you have, by creating a hood for the front, you can control the detection zone of the PIR even more accurately. This will also cut down on false triggers, especially in windy conditions.

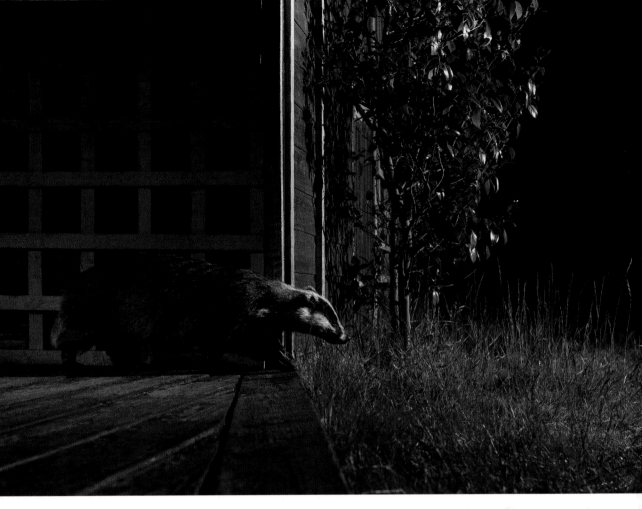

temperature, however I can often further reduce these by placing the sensor such that it aims towards a wall or the shed, rather than bushes and trees.

● **Battery Power.** Again, the question of battery power comes into play. One of the slight downsides to the Camtraptions PIR is the lack of any type of battery indicator. While the six AA cells it takes will keep it going for several weeks even if it's left on constantly, I've twice had it run out during the night because I left the batteries in just that little bit too long. Having learned the hard way, I now make a habit of swapping the batteries out after about 10 days, just to play it safe. I use rechargeable batteries, but if I were to swap them for disposable alkaline batteries, the power would last significantly longer.

▲ **50mm, 1/250, ƒ/8, ISO 400, wireless SB-28 (x2), PIR sensor.** To take this picture, a hood was placed over the PIR sensor, reducing its detection arc and more accurately pinpointing where the subject was when the camera was activated. There is always some trial and error because one cannot control the direction the subject comes from, or the speed it is travelling. Additionally, placement of the sensor is important based on the field of view your lens offers. It is worth experimenting with this, especially if you find the camera is being triggered by your subject before it's even in the frame.

By understanding these issues and how to work around them, PIR sensors make a very powerful and cheap way to work with a camera trap. Without one, I certainly wouldn't have been able to take many of the photos I have captured over the course of this project.

## MANUAL TRIGGERS

Although I have become a big fan of camera trapping, there is still something to be said for taking things back to basics and being in full control of the exact moment the shutter is fired. You can go high or low end with manual triggers, and it may surprise you to know that my favourite ones are at the cheaper end of the spectrum.

● **Simple Wired Triggers.** I've only used a wired trigger a handful of times in this project, but it's certainly the easiest way to begin triggering your camera at a distance. Various branded and third-party wired triggers are available, especially on auction sites like eBay. One thing to be aware of, however, is that if you buy one that connects to your camera by means of a very specific connection type, you may find that you are unable to buy an extension cable for it. This is not a problem if you are using it in a macro situation to avoid camera shake and you can stand near the camera. However, if you want to use it to fire the camera from distance, such as when photographing nervous birds on a perch, then only having a shorter cable may be an issue.

● **TriggerTrap.** If you have a smartphone, I would suggest looking into the TriggerTrap solution. It is no longer available from the manufacturer, but it's still sold on eBay, and the company still develops the smartphone app. The system comprises a cheap dongle that tethers your phone to your DSLR. After installing the free app, you can then use your phone to act as everything from a simple shutter-release cable, up to an advanced time-lapse intervalometer, which you could use on other projects.

Although the TriggerTrap connects to your camera's dedicated input, the other end uses a simple 2.5mm jack, so you can buy cheap extension cables. It's possible, for little money, to be triggering your camera with your phone from 10 metres (30 feet) away, making

this easily the best-value-for-money wired trigger on the market. Furthermore, the kit is available for virtually all major camera brands and models.

● **Wireless Triggers.** I can trigger my cameras wirelessly in three ways:

- Nikon's own radio-trigger setup
- The Pocket Wizard Plus III
- Camtraptions Wireless Triggers

Although I use the last of these as flash triggers, they also double as camera triggers, making them very versatile. While the first two methods can be considered high-end remote triggers, the third will fall into even the most modest budget.

Wireless triggers also come in two varieties, namely infrared (IR) and radio frequency (RF). IR triggers require a line of sight between the transmitter and the receiver, whereas radio frequencies do not require line of sight, making them more reliable and flexible. All three wireless methods above are the better, RF type.

## SAYING NO TO FLASH

Be it wired, wireless or through a trap camera, taking photos while keeping distance from your camera can be done independently of using flash, should you not want to use additional lighting units. Although such methods traditionally go hand-in-hand with artificial light, they do not need to. There is nothing stopping you from using these methods to take photos only in daylight hours.

Wired and wireless triggers can be used to trigger the camera framed and focused on a predefined spot, such as a bird feeder. Camera traps can be used to capture animals such as foxes, badgers and deer in the UK, and many others for those who live elsewhere.

Be creative and think about how you can use these camera triggers in conjunction with varying focal lengths and camera settings. See what views and perspectives you can achieve that you might otherwise not be able to with camera in hand.

▲ Radio frequency triggers allow you to remotely activate your camera from distances of several feet or more.

▶ The Nikon MC30, and many other cameras, offer basic remote-release functionality of your camera.

◀ The TriggerTrap is one of the most versatile wired remote-shutter-release cables available. In its most basic form, it allows you to activate your camera from a distance with a big red button, but within the app are a multitude of easy-to-use options, including sound and vibration activation and a plethora of intervalometer controls, should you wish to do time-lapse photography.

# BATTERY POWER

**I favour rechargeable batteries to keep my gear alive with power. In total at this time I needed an an eye-watering 60, yes 60, batteries for everything to work at once..**

At this stage my battery requirements take into account the following:

- Seven SB-28 flashguns (4 per unit)
- Two PIR sensors (6 per unit)
- Four wireless flash transmitters (2 per unit)
- One trail camera (12 per unit)

Naturally, if you're only running a one- or two-flash setup, not using wireless flash triggers and don't have a trail camera, there will be far fewer batteries to contend with, but you will still go through them at a very fast rate. Batteries can be expensive, and even the cheap ones aren't cheap if you need a lot of them. I'm sure many of you will agree that traditional disposable batteries aren't practical or financially viable, which is why early on I started using the more cost-effective rechargeables.

With my research hat on, I discovered Panasonic Eneloops, and have come to regard them as one of the better-quality options.

Although they are a little more expensive, what makes them a better choice over other similar types is they hold their charge for a very long time. In fact, if you do not use them for an extended period, they retain up to 70 percent of their charge over the course of a year. On top of this, they can be recharged over 1,800 times before they start to lose their ability to charge efficiently. As with other batteries of this type, their voltage is only 1.3V, which most electronic devices

state will result in incompatibility. However, I have used these batteries successfully for a long time now with my flashguns, PIR sensors and wireless triggers, and even my Bushnell trail camera, despite a specific warning against them. (But I should say that if you choose to use them, you do so at your own risk!)

The only downside is that, because of the lower voltage, they run out of power a little faster than a traditional battery, but this is still better that than spending a small fortune every few weeks.

▲ To get the very best out of Eneloops, a battery charger that monitors each cell individually is recommended. I originally had a cheaper brand, which failed after several months of use, and have since been using the Vapex, which I picked up on Amazon. It charges up to 8 batteries in either AA or AAA size, monitoring each as it does.

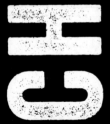

CHAPTER FOUR

# CAMERA TRAPS

**Putting it all together**

# SETTING UP & TROUBLESHOOTING

**We discovered in the previous chapter that a camera trap is a way of leaving your camera unattended, and using the motion of your subject in some way to trigger a device that activates the shutter. Now that we know what it is and what equipment is needed, let's briefly look at how to put it all together.**

## FOUR STEPS TO A SUCCESSFUL SETUP

It's all very simple and straightforward by following the rules of FFET:

• **Framing.** This is the first thing you need to do. It's essential that when you frame your image, once set, you do not move anything around in front of the camera, as I discovered the hard way in Chapter 2 (see page 75).

If you decide you want something in the frame or out of it, make that move, but then always double check on the back of the camera that it hasn't jeopardised the image. This can be especially true for distant objects. Much like when using a telephoto, where you need to keep an eye on the background, the same is true of wide angles and camera traps. Ensure nothing looks out of place or will catch the light in a distracting way.

• **Focus.** The camera's autofocus needs to be off. When working with camera traps, you prefocus your lens and then switch it to manual. This is so that when the subject trips the camera, it will take a photo straightaway. If you leave autofocus on, when the camera receives the signal from the sensor, it will start to hunt and only take a frame when it locks on. The problem there is that it may not lock onto the subject and could instead refocus far into the distance, if it locks on at all.

This need for prefocus is one of the reasons why it can take you a while to produce good images using this technique. Depending on your focal length and depth of field, having the subject in the frame, and sharp, can be two very different things.

• **Exposure.** Everything must be manually set: shutter speed, aperture, ISO, white balance and flash. This is one of the tricky things with camera trapping, because you'll need to account for the ambient lighting conditions at the time of your subject's arrival. You need to have an idea of the look you are going for ahead of time so that you can plan for that with your exposure settings.

Typically, the safe bet is to use an exposure that works both day and night, with a relatively fast shutter speed, or one that works only at night with a slow shutter speed, allowing you to record both ambient and artificial light. Using a semi-auto mode, such as Aperture Priority, will adjust for changing light levels to a degree, but will throw your flash exposure off.

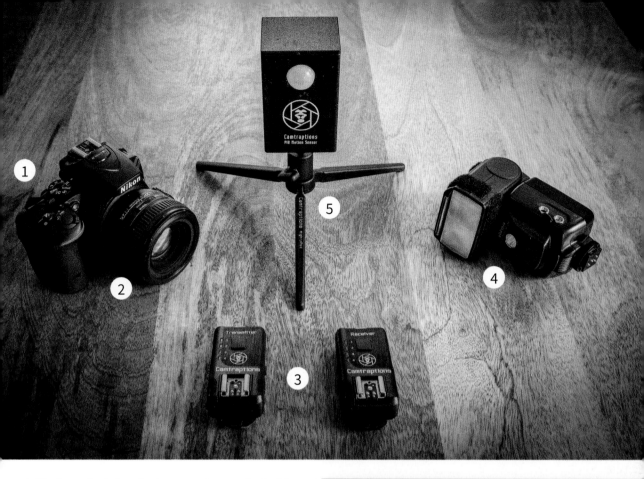

▲ The ingredients for a basic camera trap can be had for under £600 ($800), including camera and lens. (1) Any DSLR from low to high end. (2) Any wide-angle lens, as camera trapping is best suited to these. (3) A set of wireless triggers. (4) A flash. You can add as many as required, the more confident you become. (5) PIR sensor.

Shutter Priority has similar issues in that it won't drop to 30 seconds, even in total darkness, plus it could also cause the speed to go higher than the flash sync of your camera. (This is the fastest shutter speed that the camera will capture the flash, before the shutter curtains start to appear in the exposure, which is typically around 1/250 second.)

Artificial lighting examples and ideas are covered in more detail in Chapter 5 (see page 124).

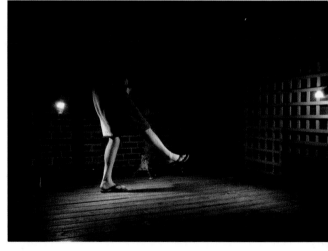

▲ Always ensure your camera trap works before walking away (dressing gown optional).

• **Test.** This is possibly the most valuable lesson of all. Once everything is set and you are ready to walk away for the day, night or week, don't. Not quite yet, anyway.

The very last thing you need to do is walk in front of the sensor and ensure the camera activates. When setting up, you'll generally be firing the camera manually, so it's very easy to forget to switch the sensor on at the last moment. If you have switched it on, don't assume it is working. Check. The batteries could be empty, the input jack might not be fully seated or a battery may have popped out of its holder slightly. I say this, because all of these have happened to me, and more besides. Always make sure the entire setup is working before you leave it. Always.

## HAVE FUN WITH IT

As with anything to relating to wildlife photography, camera traps can be as complicated or simple to use as you wish them to be. As is often the case, I find the simpler the better. I've experimented with setups that consist of up to four flashes, combining two hard and two wireless, but some of my favourite images from this project have been those taken with only one.

The best thing of all is that once set up, you can leave it and concentrate on the more important things life puts in the way. So it's a great way to keep your photography going if you are limited on time.

## WHEN THINGS DON'T GO TO PLAN

Things don't always go to plan, and this is even more likely when you are leaving a camera unattended. Sometimes, things happen that are out of our control; and sometimes, well, human error plays a rather large role. There have been many times over the course of this project where something unexpected has caught me out, or I've made silly mistakes, so rest assured that if things can go wrong, at some point they will, for all of us. When they do, laugh at them, and laugh at yourself. Unless, of course, that once-in-a-lifetime photo opportunity was missed because you forgot to turn the camera on...

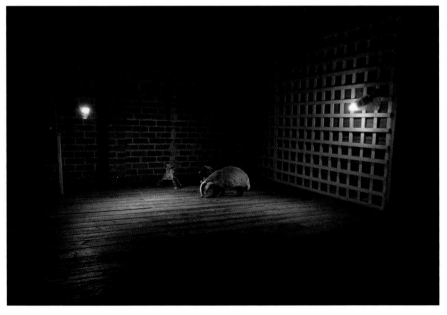

◄ A simple two-light camera trap in action. The PIR sensor and camera, wrapped in plastic bags, are clearly visible behind the badger.

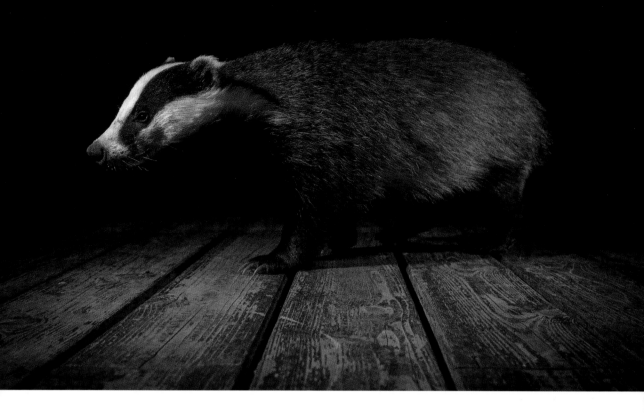

## WHY WON'T MY CAMERA FIRE?

On one occasion, I spent about two hours setting up for a shot I hadn't tried before, rearranging the previous night's setup. I played around with the framing, moving the tripod, adjusting its height and then deciding I didn't like the setup, so I changed it again.

It took me quite a while to get everything in place in a way that I was happy with, so much so it was getting dark as I finished. Finally, I positioned the PIR sensor where it needed to be and I was ready to test and set flash exposure. All that remained was to wave my hands in front of the sensor. The camera didn't fire.

I assumed the Pixel hub wasn't securely fastened so took the plastic bag off the camera, removed and re-engaged the hub. Still nothing.

My next thought was that the batteries in the PIR sensor needed replacing. I quickly went inside and swapped them over, but again, nothing. I then tried

▲ **35mm, 1/250, *f*/5.6, ISO 250, wireless SB-28 (x2), PIR sensor.** For this frame, I repositioned the camera so that the decking would create lead-in lines towards the badger. I also wanted the badger closer to the lens so that I could play with the depth of field a little, rather than having complete foreground-to-background sharpness.

swapping over to my second sensor. Nothing. I figured I may as well replace the camera battery and flash batteries too, just to be sure. I wasn't surprised, but perplexed, when that didn't make any difference either.

At this point I was becoming quite frustrated at not being able to work out what the problem was. Eventually, I went upstairs to grab another Pixel flash hub, and it was when I walked into the office (my professional name for the spare bedroom) that I spotted the cause of the problem.

Sitting on the desk was the memory card – without which my camera was set to not activate. I had spent

a total of 35 minutes trying all manner of technical fixes, and it was one of the most basic functions that had stumped me. I'd set the camera up to only trip the shutter when a memory card was inserted. I'd love to say that this was the only time something so silly has caught me out, but then I'd be lying.

## THE BEACON OF LIGHT

On another night, having set up for a new shot, I happened to walk out into the kitchen when one of the badgers had arrived. I enjoy just seeing them go about their business, so I sat at the window watching. I knew immediately something was wrong when the badger walked in front of the PIR sensor and, rather than the flashguns firing, the entire plastic bag covering the camera illuminated like a giant ball of light. I realised I had forgotten to turn off autofocus after setting up, and now the autofocus assist light was working its magic and trying to help the camera lock on the badger in the middle of the night. I spent five minutes watching the bag light up every time the badger walked in front of it, although amazingly, the camera did manage to fire a couple of times.

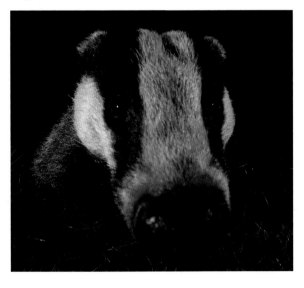

## PHOTOBOMBS

One of the more entertaining aspects of camera trapping comes in the form of the images you didn't plan to capture. You set up for one image, and quite by chance something completely unexpected jumps into the frame to steal the limelight.

More often than not, working in the yard means these bonus photos will be of someone's pet, although once or twice, you get lucky and it's something better.

It usually happens to me when I've been setting the trap up and then walked away from it, back into the house to get something. I return after a few minutes to discover the camera has been triggered by something having a quick look to see what's going on. And by that I mean, see if there are any quick snacks to be had when the coast is clear. I used to be surprised by how few birds I get in the garden, but now I've had so many photos of cats, I understand why.

## USER ERROR GETS US ALL

When I have set up my trap and I need to go out to it again later, I often find myself turning off the camera or PIR in order not to trip it if I have to walk through the beam. On more than one occasion I have forgotten to turn the camera back on again. Sometimes, I've realised it when I see the badger or fox turn up, and then sit there grumpily as any activity plays out but the camera does nothing.

On other occasions, I've been lying in bed almost asleep, before having a lightbulb moment that the camera is still off. It's not much fun having to get out of a comfy warm bed in the dead of winter to traipse down to the end of the yard in the freezing cold. Worse, perhaps, is when I get up in the morning and go down to the camera only to discover I hadn't switched the camera back on.

◀ Sometimes you can't get wildlife near the camera. Other times, you can't get it far enough away!

Over the course of the year of this project, if it could go wrong through user error, it did. Forgetting to put batteries back in, forgetting to turn flashes back on, not formatting the memory card properly so that it barely took any photos before filling up, and even the elements getting in on the act, such as the wind blowing flash cables into frame in the middle of the night, have all intervened.

▼ One of the more successful photobombs was an early appearance from the jay, before I had made a conscious effort to photograph it. With this image, I had only been inside the house for 30 seconds at most, and had no idea the jay had even flown down until the following day when I checked on the camera and noticed the time stamp. It was also the only image taken.

▲ Over the course of the year, I've been able to identify five different cats that frequent the garden, and one dog. Sadly, I have been unable to determine, as yet, which of these animals likes to occasionally leave gifts for me dotted around the lawn.

◀ I often see the squirrels in nearby trees, but I suspect the cat population prevents them from coming down into the yard very often. This one had clearly spotted me putting some peanuts inside this log ahead of an evening shoot, and took the opportunity to dash in when the coast was clear.

## SQUIRREL DISTRIBUTION

The Eurasian red squirrel prevails across continental Europe, as well as Russia, Korea and north Japan, but it is the invasive North American Eastern Grey squirrel that are shown in this book. Introduced in the 1870s, the grey squirrel now dominates in the UK, with only a few places retaining populations of red squirrels.

Squirrels are usually active during the day and feed on acorns, bulbs, tree roots and buds, nuts and fungi. They breed between January and April.

◀ The squirrels seem to visit more often in the winter. Again, this one ran across the frosty decking to partake of some peanuts left out, early one morning. The texture of the wood works really well alongside the frost, to complement the colours in the squirrel's fur. I'd never have envisioned this image for the squirrel, had it not come down from the trees and run in front of the camera.

# THE CURIOUS CASE OF THE YOUNG FOX

The most genuinely upsetting moment I experienced was in July of the second year. When the fox population was almost entirely gone, what was clearly a youngster from the year's earlier litter began visiting frequently. I was really hoping that this would begin the resumption of more regular fox photo opportunities, but sadly this was not to be.

The morning after catching my first decent image of the youngster, its body appeared dead at the side of the road, a little way from my house. It was deeply saddening to have seen the beautiful animal looking so full of life in the photo just hours before, and was a definite low point of the entire experience. I simply can't help but grow an attachment to animals that I see frequently, even the wild ones. Simply put, they become a part of your life.

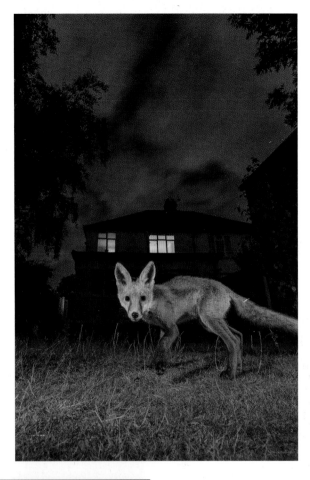

▶ I had high hopes for more opportunities to photograph this youngster, who began visiting the garden in early July. Sadly things didn't go to plan.

◀ When using a camera trap, you get many photos of yourself setting things up. They aren't nearly as much fun, however, as the ones you get of other people – especially when they're wearing shoes that are far too large for them! My wife has been so accommodating throughout this project, it seemed wrong to not include her in the book somehow...

# ADVANCED PRINCIPLES

## Controlling creativity

# ORDINARY TO EXTRAORDINARY

**Once all the technical equipment puzzles are out the way, the real fun of working at night can begin. This is when your perspective of how things look, or can look, will change. It took me a little while to grasp this, but it proved to be one of the biggest photographic eye-openers I've had.**

Although we associate the darkness with a lack of ambient light, which is ordinarily not conducive to wildlife photography, that low light can actually help us capture images that are quite different from those taken in the day, and I believe the creativity it affords you should be fully embraced.

The use of long exposures to capture the low ambient light, and balancing that with fill flash can be very effective, as can the use of a fast shutter speed to let in only artificial light. Both methods can be exploited to create a dramatic effect within the frame, one that looks completely different to how it would during the day.

That, I believe, is a key point in this type of photography, and retaining that feeling of the night is very important to me. All too often I see images artificially lit at night, where the entire scene looks like it's been shot in the middle of the day. For me personally, a more subtle approach that retains that feeling of darkness is more appealing and representative of the scene I am capturing. It's more creative, has more drama, and it helps tell a story.

## SEEING WHAT CANNOT BE SEEN

The trick is to see beyond what's right in front of you during the daylight hours, and to ignore the way the sun illuminates the world. Instead, previsualise how the scene might look when you have full control of the main source of light.

With most nighttime work, that requires the camera to be set up ahead of time. Learning to do this is essential, and it's an ongoing process, but the reward is significant. I say this because not everyone has a picturesque, well-maintained yard in which to take photos, but that shouldn't be a mental stumbling block that stops you from exploring your options. The night can hide a multitude of sins, and you can transform a scene that would be forgettable during the day into something beautiful and eye-catching by night.

The images opposite are a simple demonstration of this. They show how a boring and messy frame later became the scene for a far more interesting image, once darkness fell, and I had full control over what would be lit and how.

As can be seen from the top image, even if the badger or a fox had visited then, it would not have

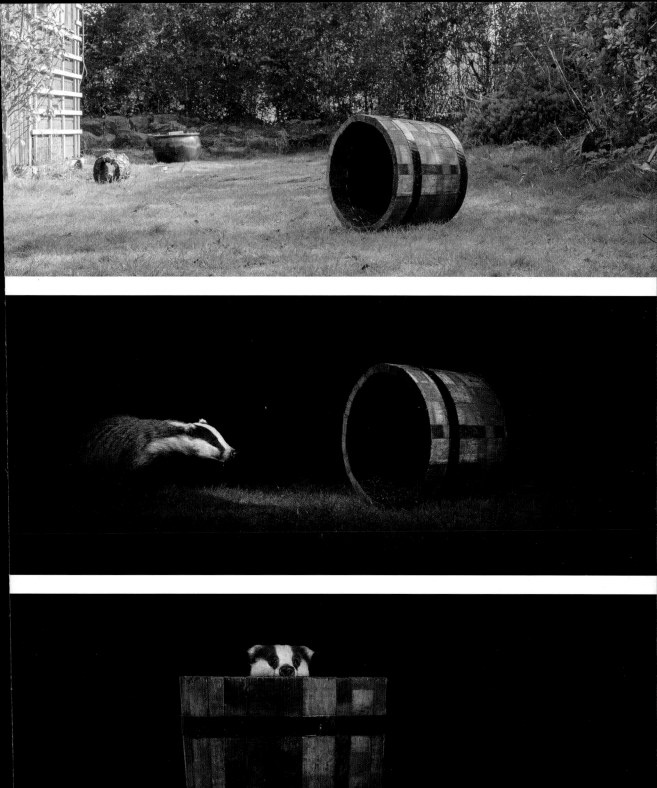

been enough to make it an interesting photo. The backyard looks a little rough and ready, and there are some distractions in the background. So I placed a flashgun at either side of the frame, with one attached to my fence and the other to a garden bench just out of view, and decided to concentrate the light onto the area around the wooden plant pot.

Once darkness fell, I used a fast shutter speed and relatively low ISO to ensure there would be no ambient light captured on the sensor, and the light from the flash would not spill out too far into the yard. That control of the light is all that has changed between the images. The camera is in the same position, yet the photos are a mile apart in their look and feel.

I was quite lucky when experimenting with this setup, because it was early spring, when badgers are very active. At the height of this activity, I was averaging up to four visits a night, enabling me to really play around with lighting setups and capture some fun photos. Remember, although a handful of peanuts or other treats will get an animal roughly where you want, there is no way of knowing the direction they will come from or what they will be doing when the camera takes a photo. There have been many more failed images than successful ones.

## BALANCING AMBIENT LIGHT

Balancing ambient light is certainly easier when using relatively fast shutter speeds; it can become tricky when using slower ones. You may have noticed that many of my images have been taken at 1/250 second. At these speeds, you can still record a lot of ambient light during the day and reduce ghosting of the subject, but at night, you essentially rely on your flash for the light source unless you slow the shutter down drastically, which will allow more ambient light back in.

This is where things get interesting. With slow shutter speeds, I generally opt for around 30 seconds so that I can capture the night sky to add an extra

element of interest. This poses two issues. The first is having something interesting happen in the sky, either a clear night full of stars or some interesting clouds; and the second is combatting the weather, which has an annoying habit of not matching the forecast. Countless times the weather has been predicted to be clear for the night, and so I have set the camera up for a long exposure shot, only to check the camera the following morning and discover clouds rolled in. A cloudy sky isn't the only thing to ruin the image though; that extra light has another effect.

## LAYERS OF LIGHT

You will have noticed that some of the images within these pages feature sharp subjects with up to 30-second exposures. The theory behind this is simple and relates back to how exposure doesn't rely on the shutter speed. The same is true of moving subjects. When using flash, the shutter speed is not what freezes them in motion: the flash is. This is fine for fast shutter speeds, but when working with longer exposures, there is a little more to it.

When the camera starts the exposure, the flash will fire and light the subject in the frame, exposing them for that split second, catching them in time. However, there can still be up to 30 seconds' worth of ambient light yet to expose on the sensor. If the subject remained motionless for the duration of the 30 seconds, then ghosting would not be an issue. However, because these are living creatures that don't sit still but continue to move around after the flash has fired, ghosting happens when the ambient light begins to re-expose the parts of the image that were hidden by the subject, when the flash first fired.

The way the sensor exposes light is that anything bright will expose over anything dark, not vice versa. Once something very bright has been exposed, nothing dark will be able to expose back over the top of it. This is why car light trails show up in long-exposure photos, and you don't see the cars in the final image.

When the sky is dark, you need to set an exposure that will allow enough ambient light in to record the sky in some detail, but not so much that the ground exposes too brightly. That way, when the flash lights up the subject, it will remain a bright enough source of light on the sensor that once the subject has moved on, the background does not start to re-expose. This is why those cloudy skies can and will do much damage

▶ The brightest elements in the image will always expose over darker areas during a long exposure. Balancing these layers of light is key. Even light cloud cover can be a problem, reflecting streetlight at the ground and overexposing parts of the image.

▼ **18mm, 1/200, ƒ/8, ISO 400, wireless SB-28 (x2), PIR sensor.** Drama can be added to even the simplest of scenes by playing with how you illuminate the world around the subject. Here, shafts of light add drama to a badger under a bench, which is an incredibly simple concept and one that could be quite uninteresting.

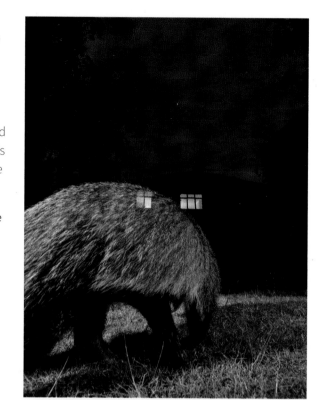

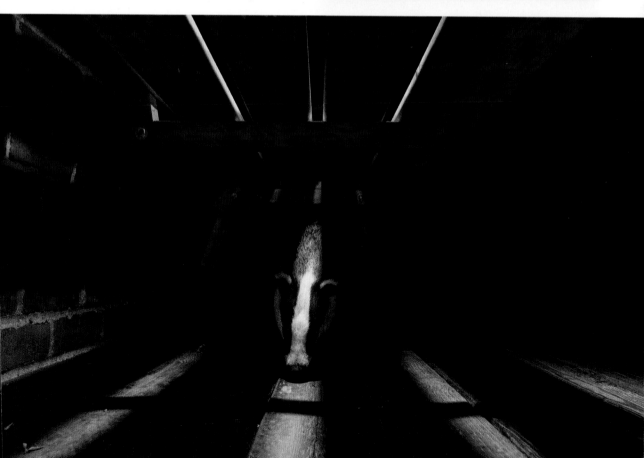

▶ The two photographs on this page show how using ambient lights and different sources of artificial light can transform the scene. By day (right), the view of the house is uninspiring. The light is flat and dull and the sky overcast. Even with a clear blue sky there would be nothing of interest here, even if an animal did happen to walk in front of the camera.

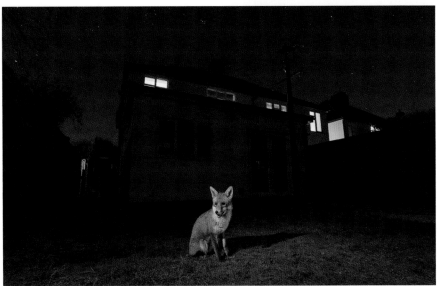

◀ **18mm, 30 seconds, ƒ/8, ISO 800, SB-28 (x2), PIR sensor.** At night there is a dramatic difference. The star-filled sky and house lights work in conjunction with the two flashguns to create a strikingly lit image that is a far cry from the same view earlier in the day. The lack of ambient light also allows the fox to appear to remain solid, even though it would have walked off during the long exposure.

if they roll in unannounced, reflecting ambient light back to the ground. It's not just cloud cover that has to be accounted for to prevent ghosting. Exposure settings in general need to be carefully set. Allow too much light in and you'll have problems. Don't let enough light in and the image will be very dark, and due to the high ISOs, it's a struggle to recover shadow detail. The resulting image will be unusable if recovered from such extreme underexposure, even shooting Raw.

The moon, depending on its angle in the sky, its size and the time of night that it appears, it can also throw a few complications at you. However, unlike the reflected ambient light from cloud cover, the light the moon casts on the scene can really elevate the frame to something quite beautiful and almost otherworldly, introducing wonderful blue light and interesting shadows. Capturing this in the frame, however, is a little tricky. Even though the moon on a clear night can throw out a lot of light, long shutter speeds are still required. I've only managed to successfully capture moonlight a handful of times, in part because there is some luck involved. Apart from framing the image, you need the subject to appear when the moon is in the

right place in the frame or sky. That is, only on nights when the moon is going to be in the right part of the sky at all, and the sky is clear. The opportunity to get such shots is understandably quite rare, and having everything come together when the opportunity does arise, equally so.

Working with 30-second exposures is a constant battle between balancing ambient and artificial light. I've had nights where the sky was clear, but no subject came. Nights where the subject arrived, but there was cloud cover that wasn't forecasted and, of course, nights where the subject turned up but the ambient light was too much, and the subject became transparent during the long exposure. Very frustrating but, equally, so very rewarding when it pays off.

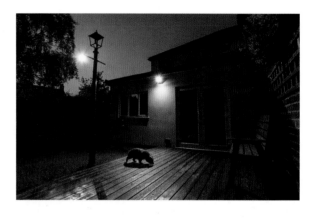

▶ **18mm, 20 seconds, ƒ/9, ISO 800, wireless SB-28 (x2), PIR sensor.** When you pull it off, including the moon or strong moonlight in the frame works very well to provide enhanced atmosphere.

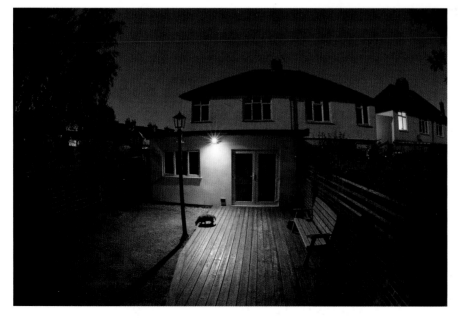

◀ **15mm, 30 seconds, ƒ/8, ISO 1000, wireless SB-28 (x1), PIR sensor.** In this example, with a clear sky forecast, I knew the potential for having the houses lit by moonlight would be high.

# WEATHER WORRIES

**Unexpected weather can cause exposure problems, such as the previously discussed issue of nighttime cloud cover, but more than that, it's imperative to keep an eye on the forecast for any potential rain and, especially in the winter, condensation.**

## FOGGING FRONT ELEMENTS

The dew point. Little did I know this was something I would become all too familiar with when I first started leaving my camera out overnight. The dew point is the temperature below which condensation begins to form on surfaces, such as camera lenses that are left outside all night. If it happens, it ruins your photos pretty quickly. I check an app called Weather Pro, which tells me the dew point temperature, in the evening before I put the camera out and compare it to the current temperature, and the coldest temperature predicted overnight. If the coldest forecast is below, or very close to the dew point, I know there is every chance the lens will fog up in the night.

I tried a couple of ways to stop this happening. The first was to place a filter covered in an anti-fog solution on the lens. Although recommended by a couple of photographers, I couldn't get on with it. I tried two different sprays and the result was either that the image was blurred because of the thickness of the extra coating, or the spray wasn't effective and I still had fogging.

It was clear the best way to stop dew forming was to combat the very cause of it, and find a way to keep the temperature around the front element high enough that condensation would be unable to build up in the first place.

I researched several methods for achieving this and discovered it was something the telescoping community are well prepared for. It appeared that, among the stargazers of the world, dew is also a problem and as such, there are several options on the market for keeping a telescope from forming condensation. One method came in the shape of a Dew Controller, which is a strip of material that you wrap around the telescope (or lens) which is heated via a battery.

This would have been the perfect solution had it not been for the initial cost, plus the need for yet another power source. It seemed a complex and costly solution for something that I wanted to try and keep simple.

With the idea of a heat source still whirring around in my head, I decided to try using chemical hand warmers. I looked online and found that, while they are aren't the cheapest, buying in bulk was a cost-effective way to stockpile them. For the first test, I tried to attach one to the lens with an elastic band. Much to my surprise, and delight, the following morning when I went out to check on the camera, I discovered it had worked. In fact, there was still a little warmth left in the hand warmer even though it had been out all night.

▼ The effect of condensation on the lens is very apparent. Contrast and sharpness are lost in the centre of the frame as it builds. If the temperature drops, this only gets worse. Despite the flashguns being placed at the peripheries (note the single catchlight for each), the glazed pot reflects them and would be a major distraction even without the condensation.

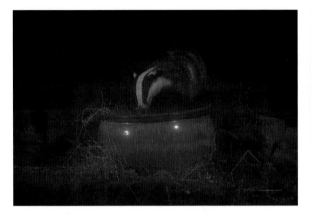

▼ The following night, despite the dew point's best efforts, condensation has not built up on the lens thanks to the Lens Wrap. In addition, I also repositioned the pot to allow for better positioning of the flashguns. This let me remove the distracting bright spots on the glazed surface of the pot. All this demonstrates how quickly you can turn a bad image around.

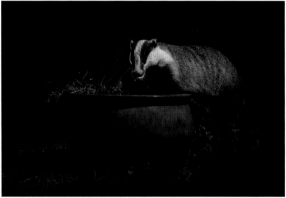

So that was the dew issue fixed. Now I just needed to implement it in a slightly more elegant solution. Although using an elastic band to attach the hand warmers to the lens was alright, it did risk interfering with the focus ring when taking them on and off. Something that was quicker and easier to attach and remove was required.

I got in touch with the UK-based Wildlife Watching Supplies, a manufacturer of camera covers and other accessories. I explained what I was doing and asked them to make me a cover to wrap around the lens, but one that contained a pouch inside, in which I could insert a couple of hand warmers.

I soon found myself in possession of the prototype of a Thermal Lens Wrap. It certainly solved the issue of condensation, as I've had the camera out on nights where the temperature has dropped down as low as -5°C (23° F). The following morning, the yard would be covered in frost but the entire plastic bag covering the camera was completely dry; the heat had prevented any condensation from forming, let alone freezing. It was highly effective.

◄ The Wildlife Watching Supplies Thermal Lens-Wrap. It holds up to four chemical hand warmers and, once inside the band and wrapped around the lens barrel, prevents condensation building up on the front element by keeping the lens temperature above the dew point.

## FROST AND RAIN

Then, of course, there is wet and cold weather.

Frost is only a problem on the coldest of winter nights, but as a matter of course, I always ensure everything is wrapped in plastic bags, so that no moisture can get through to any electrical components. As a byproduct of keeping condensation off the lens, the Thermal Lens Wrap (see page 130–31) also does an incredibly efficient job of stopping frost from forming on the camera cover.

Rain has caught me out on several occasions now, especially early on when I didn't check the forecast carefully. I now endeavour to keep an eye on the weather at all times when placing the camera out, always ensuring it is covered, and more importantly, shielding the front element to offer as much protection from wet weather as possible. This can be tricky, especially if it's windy, but I am often able to concoct some makeshift way to achieve this.

I've done everything from putting an umbrella over the top of the camera to putting the camera under the garden bench, with a bag placed over the bench seat. I've even placed food containers balanced on bricks over the top. As long as it gets the job done, it really doesn't matter what it looks like. Other than keeping the rain off, the only problem is that because more often than not a wide-angle lens is being used, sometimes you can only provide so much cover before it starts to become visible in the frame.

On occasions, the weather has swept through and caught me off guard, resulting in a very wet-looking front element in the morning. Initially, this really worried me, but now I'm not too concerned. That said, any equipment on loan from friends is never subjected to the elements, because that one day something does go wrong, it's almost certain to be the borrowed equipment that suffers.

Generally, the most important items to keep water off are the camera and flash, because electricity and water do not mix. So I always ensure both camera and

▲ Batteries may drain faster in the cold, but as long as you keep everything well wrapped in plastic, your equipment will remain safe and protected from the elements.

flash are very safely wrapped up in plastic bags. And furthermore, I often gaffer tape the plastic bag to the lens hood to ensure a snug, water-tight fit.

▶ There have been times that my waterproofing hasn't gone entirely to plan. It's rare, but it does happen. The biggest culprit is often the wind, as it can blow rain towards the camera. In this instance, the wind had picked up during the night and directed a particularly heavy downpour towards the lens. To add salt to the wounds, no photo was taken overnight either.

◀ The results of a wet front element are nothing more than frustrating. On this, one of my early setups, you can see I had the PIR sensor too near the edge of the frame, giving the soft black vignette camera-right. The camera was triggered by a fox as it walked along the back of the house, out of the flashguns' reach.

▼ Despite the potential pitfalls, it's worth working with the rain. Don't shy away from it, and you will be rewarded by photos that are far more appealing than those without.

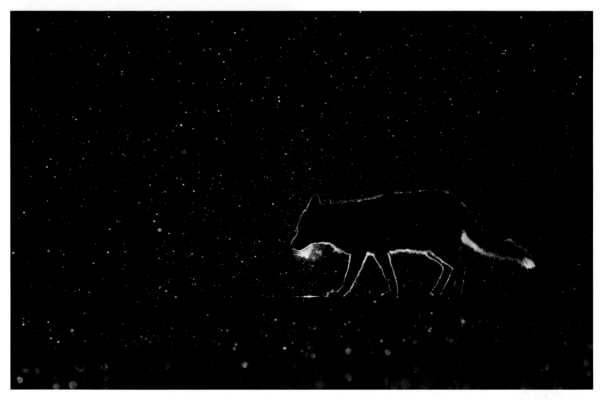

CHAPTER SIX

# DECONSTRUCTED PHOTOS

**Conception to completion**

# FESTIVE FOX

**With no snow on the ground, I decided the best way to approach a photo for the holiday period was by a including a Christmas tree. There was only one catch: I didn't have the idea for this photo until December 29th, and for it to really count, it had to be taken during the official days of Christmas. I needed to move the Christmas tree away from where we had originally placed it into a more suitable position, which I did until January 6th, when the tree would have to come down.**

Of course, I could have just left the tree up until I had secured the photo, even if that took a month. I felt it had to be taken during the right time period, however. Photography is all about setting difficult goals, and when you meet them authentically, it's always far more satisfying than cheating.

I had two challenges to overcome with this photo. Both were equally important to the success of the image. The first was combatting the dew point (see pages 130–131) and the second was how to light the image so that the required flashguns did not reflect all over the glass doors.

I placed the camera in position, and my first task was to set the exposure for the ambient light of the Christmas tree in the house. In isolation, the tree lights were not bright enough, so I also placed a lamp on the dining table to give an extra warm glow to counter the colder light outside. I arrived at an exposure of 1 second at $f/8$, which I was slightly worried would cause some ghosting of the fox if it moved too quickly, but it was a good balance of low ISO, and the most

important aspect of the image was to get the ambient light right first. With the exposure set for the ambient, I then balanced the outside exposure with the flash.

My setup for the image was comical. I had placed my bench behind the camera, so that I could hang an umbrella over the top. There were two reasons for this. The first was to prevent any potential rain splashing on the front element, and the second was to stop the front element being directly exposed to the sky, in an attempt to reduce any buildup of condensation.

The first night, something triggered the camera, but there was nothing in the frame. This was fine because the lens had condensation on it anyway. The bigger problem arose the following day, when some friends visited and we gave them their presents. Suddenly the space underneath the tree looked a little sparse with only a couple of gifts remaining. I'd be lying if I didn't say I was tempted to wrap up some empty boxes to replace the missing gifts.

● **December 30th.** I placed a filter over the front of the lens and tried to use some anti-fog spray that had

been recommended. The fox visited quite early, and even better, it was a bitterly cold night with frost all over the floor. It looked magical. Except when I zoomed in on the image, the anti-fog spray had basically made the entire frame look like I smeared grease over the front, which I guess, essentially, I had done. As if that wasn't insult enough, another photo taken later showed the lens had fogged up anyway.

- **December 31st.** I set the camera up again without the filter. The vixen showed up, as did the badger, in a rare winter guest appearance. The badger was in the shadows and the fox too near the house with its shadow cast. It was clear I needed to make some further lighting adjustments. Unsurprisingly, the lens fogged up again.
- **New Year's Day.** The only photo I captured was of myself, setting up the camera.
- **January 2nd.** The Wildlife Watching Supplies prototype Thermal Lens Wrap arrived. I'd already stocked up on chemical hand warmers so I was ready to go. That night, I didn't catch the fox in a good position, but everything else was perfect, and crucially the lens did not fog up.
- **January 3rd.** Everything fell into place with the fox strolling perfectly across the frame with no ghosting, despite the slow shutter speed. The only thing that could have improved it would have been a repeat of that beautiful covering of frost from a few nights before.
- **January 4th.** Frost again. I went to check on the camera before bed and saw the umbrella had been blown over in front of the lens. Annoyingly, something had also triggered the camera. Nothing else came that night and I still wonder to this day what was behind that umbrella.
- **January 5th and 6th.** Nothing visited for the final two nights. I didn't quite manage the frosty floor I wanted, but the shot from January 3rd worked very well; a light sprinkling of rain had allowed the glow of the house to reflect a little on the decking. See the final image overleaf.

▲ My efforts to keep the front element dry consisted of a balancing act between an umbrella, the garden bench and a couple of bricks, placed against the handle to hold it in position. You can also see one of the two well-wrapped flashguns in position pointing towards the house; the other, just out of sight on the right, was poised to fire across the decking – placed so as not to cast a shadow of the PIR sensor on bricks (just visible bottom right).

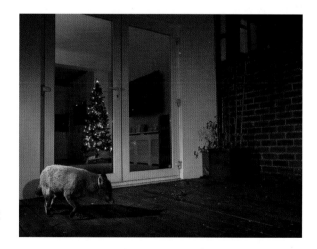

▲ Lighting this scene was very tricky. I need to get a good balance between the light inside the house, and a fast enough shutter speed to not catch movement in any subjects. Furthermore, lighting the outside of the house required pointing a flash at it, so shielding the light from the reflective glass also took some trial and error to look natural.

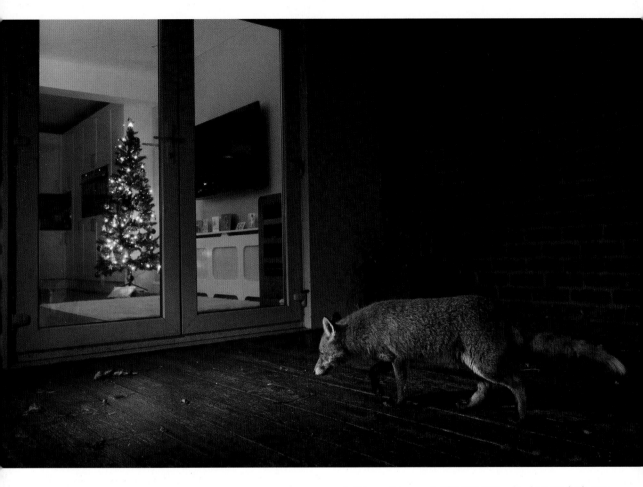

▲ **30mm, 1 second, ƒ/8, ISO 400, wired SB-28 (x2), PIR sensor.** With the shutter set to a relatively slow speed of 1 second, there was still a risk that movement would be ghosted slightly from the ambient light. Thankfully, that was avoided, and after several nights everything fell into place for one single frame. The lighting worked well, and a slight shower had just started to wet the decking, reflecting the warm glow of the house lights.

# NIGHT PATROL

**The initial idea for this image came right back near the time I first discovered the badger was visiting, and it's an image I kept trying to refine ever since.**

I borrowed a friend's 35mm lens because I needed something a little wider than my 50mm to get the house in the frame. The aim was to capture a shot of the badger with the house behind, showing its urban surroundings and conveying the message that we unknowingly miss an awful lot of what goes on in the natural world, often right under our noses.

Initially, I was limited with framing, because our old security light was hanging off the wall unattractively. Nevertheless, some careful camera placement allowed me to hide the light behind a lamp post in the garden. I spent about two weeks trying to get a shot of the badger with the house behind it. It was a sporadic effort as, with the camera on the floor pointing upwards, I could only attempt this when it wasn't raining, and as we were approaching winter, dry nights were becoming less frequent. I had some early success, although with the lights on in the house, I felt it looked very empty and distracting (see Evolution 1 on page 141). I then decided to have a light on upstairs only so that the kitchen wouldn't look like a big empty box. This yielded mixed success, but I wasn't happy with the contrast between the flash and ambient light; with the badger in the foreground it almost looked like it was two images combined (see Evolution 2 on page 142).

I then had the idea of trying to light up the house as well as the badger, to create even illumination across the entire scene. This is where things became a little tricky and my ambition got the better of me, as doing this required two wired flashes and two wireless flashes, controlled through PocketWizards. As well as the two flashguns used to light the foreground, I placed another on the floor behind our lamp post, pointing up at the house, and a fourth on the roof of my extension. This involved me climbing out of the bedroom window each evening that I wanted to attempt the shot. Because I didn't want to climb out of the bedroom window onto the roof in the middle of the night, I constructed a cradle for the flash, which allowed me to pull it back in through the window, without having to climb out on the roof (see page 140).

Looking back, I have to laugh. When you are learning something new, you have to go through these phases to come out the other side and know what works, what doesn't, and how to make things that do work, do so more efficiently.

I was relatively pleased with the results but I now had the opposite problem. Whereas before, the images looked a little unnatural because of the clash between ambient and artificial light, it now looked unnatural because the house was lit up like a Christmas tree. Shortly after I had to return the 35mm to my friend, so my lack of wide angle dictated I moved on to other photo ideas.

## A HAPPY ACCIDENT

Now that I had gained a better understanding of how to balance different light sources (and replaced the old security light), I had more compositional freedom. I also added an 18–35mm lens to my kit bag.

I positioned the camera low to the ground, off to one side, with the lens set to 18mm. This provided a good perspective looking upwards, showing the house and sky above. I placed one flashgun camera right, attached to my shed, and a second at camera left to provide fill for the shadows. With it being winter and activity being almost completely gone, the camera spent a month in this position before I captured a single image worth keeping. It was good, but I knew I could do better when the conditions were more favourable.

April arrived, and with animal activity much more frequent again I decided it was time to have another go at this image. With two badgers visiting almost nightly, I was getting images, but the positioning and poses were not quite right. I remember checking the camera one morning and being thrilled to see a shooting star in the frame above the house and the sky a lovely blue colour. The badger was in a perfect position and I was very excited to get the image on the computer. Sadly, disappointment quickly followed when I did, because the badger was suffering from the dreaded ghosting. He had made an earlier visit than normal, and because of that, the ambient light was still quite bright, hence the lovely deep blue in the sky, resulting in the white of the house catching the light and showing through his darker fur.

Undeterred, I carried on. A couple of days later, I checked the camera one morning and found several frames captured. One of them was just what I had wanted. The badger walking towards the camera and a relatively clear night sky. However, it was one of the failed frames that really caught my eye.

The night before, I had gone into the kitchen to see if anything had visited. Switching on the security light revealed the badger on the lawn in front of the camera. I turned the light off straightaway but the resulting image

▲ I made a crude cradle using tape, card and string so I could pull the flash and PocketWizard in from the roof.

exhibited motion blur from the extra light source. With the security light, however, the look of the image worked really well (see Evolution 4, page 142). I knew a 30-second exposure wasn't possible with the security light on, so I purchased a 30-metre (100-foot) ethernet cable to run back to the house, and balanced a third flash on top of my security light. This would give me the exposure control I needed but give that extra dimension to the image, by replicating the job of the security light.

In a couple more days I ended up with the frame I was after, and it's a nice progression from those original images I had taken months before. Jupiter, visible in the sky above the house was a welcome extra that I hadn't planned at all, but balances the sky nicely with an almost perfectly composed position (see page 143).

I like the story this image tells. We often see security lights come on, be it our own, a neighbour's or a stranger's as we walk down the street at night. We always assume it's a cat or maybe even a fox. Next time you see one, stop and think maybe, just maybe, it's a friendly local badger going about its business.

I love the idea that in the dead of night when the human world is sleeping, these animals undertake their routine patrols and are probably setting off security lights all over the country without many of us ever knowing.

It's an important reminder that we can coexist on this planet with our wild neighbours.

▶ I ran a 30-metre (100 foot) ethernet cable to position a flash above the security light to replicate its light but also provide the exposure control I needed.

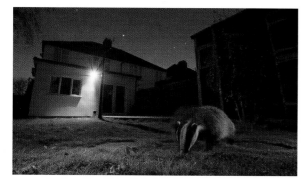

▲ The security light had a clear effect on the exposure: subject ghosting and white balance clash on the grass.

▼ **EVOLUTION 1.** My first attempt to photograph the badger with the house in the background. Early on I wasn't sure how to light the house, and results are mixed. The badger works, but the house looks empty and soulless. The contrast between ambient and artificial light also jars.

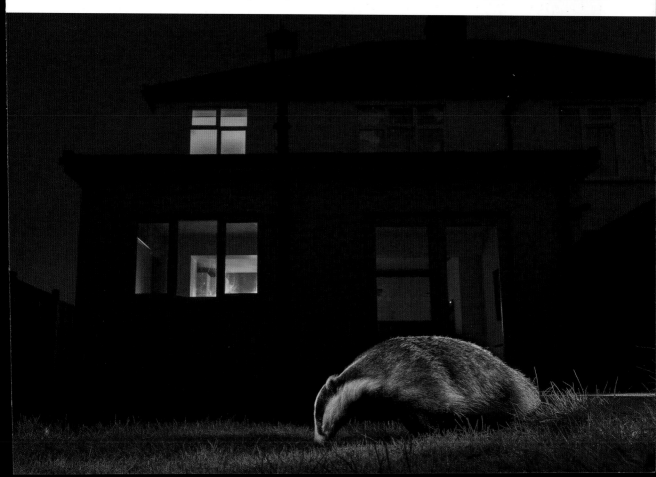

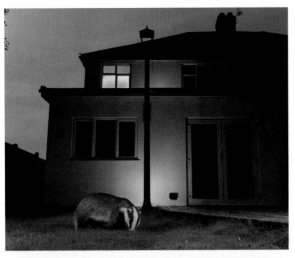

◄ **EVOLUTION 2.** To combat the clash between artificial and ambient light I then tried lighting up the outside of the house. It was an interesting result, but unnatural looking for a different reason. This was also a little elaborate, in that it required four flashguns – two for the house and two for the badger. I was drastically overcomplicating things for myself.

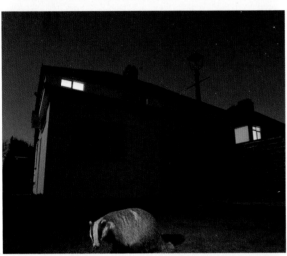

◄ **EVOLUTION 3.** Four months later, armed with a new wide-angle lens, I returned to this image. The security light had been replaced, so I had more freedom to compose the image, and I had become a little more accustomed to working my exposures at night. It took almost a month before this badger walked into frame on a clear, moonlit night, but it was worth the wait.

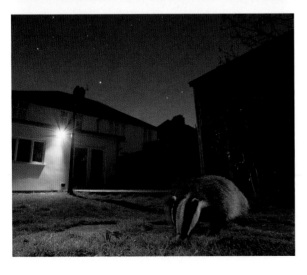

◄ **EVOLUTION 4.** One night, I turned on the security light to see if the badger had visited, and the light revealed him to be right there. I turned it back off, but even that one-second burst of illumination caused issues that ruined the image, creating ghosting and unwelcome colour balance between it and the flash. The image was also overexposed.

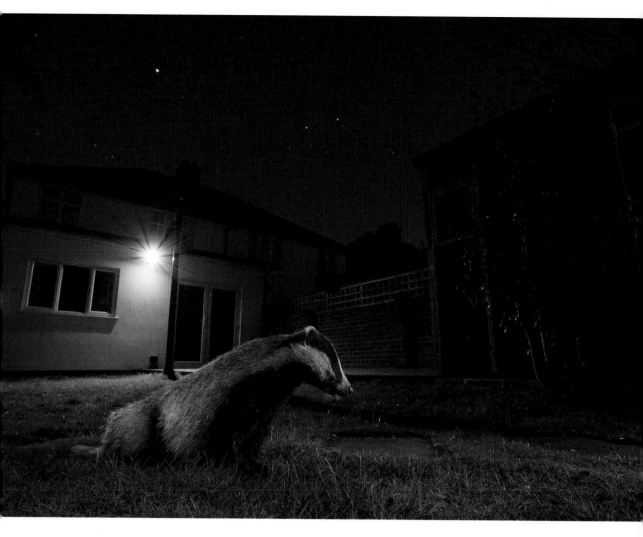

▲ **18mm, 30 seconds, ƒ/9, ISO 1600, wired SB-28 (x3), PIR motion sensor.** The failed shot gave me the inspiration of where to take the image. After seven months trying, I was able to finally evolve the shot into something I was really happy with.

# INTERSECTING WORLDS

**The image on page 147 is another one that came about through a happy mistake. Having taken many frames that linked the world of the badgers and foxes with their urban environment, by way of the camera looking back at the house, I wanted to try an inside-looking-out perspective.**

I had wanted to do this for a while, but initially the only way would have been to trail some very long flash cables out of an open window, and into the backyard. With it being winter at the time, this wasn't an option, but had it been warmer, I wouldn't have been happy leaving any downstairs windows open all night while I slept, in any case.

However, when the wireless flash triggers became part of my kit, I very quickly started to explore this different perspective. Toying around with a few framing options, the initial photos were okay, but they didn't really show the connection between the human and the wild that I desired, partly because the camera was essentially just pointing out through the back door. It was a lazy and not particularly inspired composition.

I then placed the camera closer to the door and turned it to more of a right angle, so that this time as well as the backyard, you could also see enough of the room inside to add some interest. The wireless flashguns worked perfectly and thankfully, with the 2.5mm cables being cheap, I risked sandwiching the PIR sensor's cable in the door. There was nevertheless an audible sigh of relief when it didn't fall away from the door in two pieces, as I pulled it shut to see what would happen.

## LIGHTING THE FRAME

With the equipment all ready and good to go, it was then a case of getting the lighting right. I had my two flashguns outside to light up the decking, and a 30-second exposure set to capture as much ambient light as I could from outside. Because I knew the house would be completely dark, I initially hardwired a third flash, by connecting the Pixel Componor to the wireless trigger on the camera. This would provide a little fill inside the house so that it wasn't rendered too dark.

The first few nights were a little hit and miss, with the badger either being on the lawn too far from the camera, or, if he was on the decking, it wasn't in the right area to be facing the camera. I'd also capture the occasional photo of one of the two rats that had taken up home nearby. Each morning I was also greeted with anything up to a hundred completely white frames, where the camera had been triggered after sunrise, I suspect by pigeons.

◀ ▼ I had the simple notion of capturing the badger on the decking, from the inside looking out. I placed the camera close to the door at an angle, framing the camera so that the image was almost cut in two, with the right-hand third containing some household interest. This gave me plenty of room to try and capture the badger in position to the left of frame.

# A RAT'S INSPIRATION

A few days in, I managed to get the badger in a great spot although facing out of the frame, so I left the setup in place a little longer. The following night I didn't get anything decent, however another image caught my eye. At some point before I was fully set, I think one of the rats must have triggered the camera, because although the little chap had done his best to sabotage the shot, the point at which he did so was while the hallway light was on downstairs.

This light had two effects: the first was it lit the inside of the kitchen up in a lovely warm, homey glow, which by comparison made my original flash-based fill-light look quite stark. Second, it beautifully reflected the kitchen in the window, with the line of the rug flowing out into the yard and lining up almost perfectly with the angle of the decking. It lent the image an entirely new feel giving the impression of the house carrying on out into the yard, and really tying the inside and outside together. It was an easy decision to leave the camera exactly as it was for a few more nights.

There were several 'almost' shots. In one of these, it had rained overnight, and the badger was reflecting in the decking a little, but he'd crossed slightly into the reflection. A couple of other frames over the days had him perfectly placed but generally facing the wrong way or in some other position that didn't balance framing.

In all, from inception of the original idea, it took eight days for all the elements to come together and the final image to appear on my memory card. It's one that I think ties our two worlds together quite beautifully and complements my *Festive Fox* photo (see page 139). In that photo, we're seeing our lives from the animal looking in; but here, we're seeing them from our world, looking out.

◀ This failed image inspired the changes needed to improve the shot I wanted. Before I had turned the flashes on, a rat that pops up from the decking on occasion tripped the camera. The house lights were still on, and what resulted was a really nice juxtaposition between the inside and outside worlds.

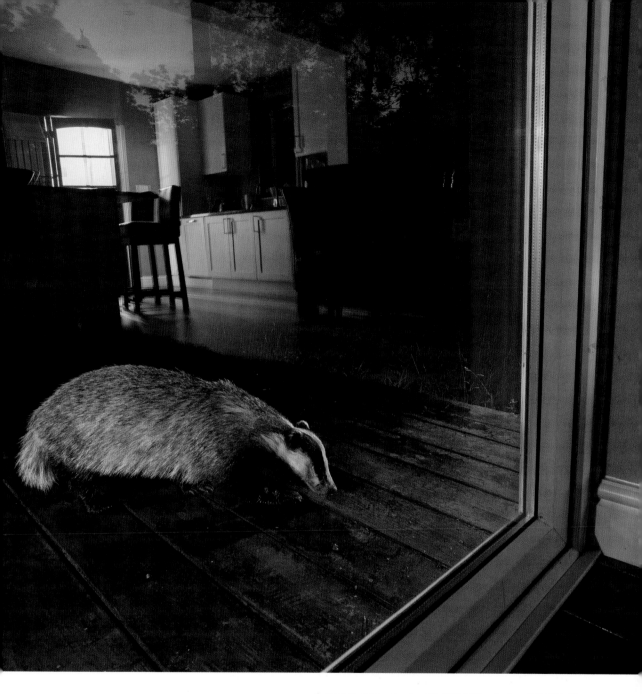

▲ 18mm, 30 seconds, ƒ/9, ISO 800, wireless SB-28 (x2), **PIR sensor.** Once all the elements of my idea of where to take the image were embedded in my mind, it took a few more nights before they all came together in the right way, and the image was secured.

# SHADOW WALKER

**Urban fox photos have become increasingly popular in recent times, especially with such an abundance of subjects in the UK.**

There are some incredibly talented photographers making full use of this population, and they're producing some stunning work. This does, however, make it increasingly difficult to approach such subjects from a fresh perspective. It was something I was determined to try to do, but it would take me more than six months from my initial idea to finally capturing the image I was after. Little did I know the impact that photo would have when I first saw it on the back of the camera.

## THE CONCEPT

The thought process behind Shadow Walker came to me in the early days of my project and was all thanks to not having had our security light replaced immediately after the building work. The resulting lack of outside light required me to shine a light out through the back doors of the kitchen to see what was happening outside after sunset. One night, the fox appeared from its usual gap at the end of the decking and as it walked through the torch light, it cast a wonderful shadow of itself onto the shed. In that instant I knew that capturing the shadow on camera would make for the unique twist to the urban fox photo that I was after.

I had a couple of initial thoughts about how to approach the image. The first was that I wanted the wall, and therefore the shadow, to be square and not at an angle. My idea was that the shadow should appear exactly as it would if it were the animal itself in the frame. Essentially, I needed the fox itself to be invisible, so that I could shoot 'through' it to the wall behind. My wish for a transparent fox was a little far fetched and so, using my tripod, I set about raising the camera high enough off the ground that I could shoot over the top of the fox. In addition, the camera needed to point down at such an angle that the resulting image would still look as though it was taken relatively head-on.

The second challenge was having the fox walk between the camera and the wall at such a distance that it was close enough to the wall to create a well-defined shadow, but far enough away that it wouldn't start to encroach the bottom of the frame. To judge the rough distance required, I used a crate that was an approximation of the height of the fox, and made a note of where on my decking the 'point of failure' was. If the fox crossed this point, I knew that there was a good chance it would appear at the bottom of the frame.

I set the camera up and spent two nights sitting at the window, into the early hours of the morning, awaiting the arrival of the vixen. There was a visit on the first night, but she only walked between the camera and wall once and when doing so, she was right up close to the flash gun. I knew the shot wouldn't work, so didn't even fire the camera.

On the second night, I had a little more success, with the vixen walking roughly in the right area, and I managed a single shot. Reviewing the image later, it was okay. Certainly a step in the right direction, but the position of the fox's head was a little awkward. Regardless, I figured it was a relative success, so I moved on to other ideas.

▼ ▼ The stage was set. With the camera framed up and the PIR sensor and flash in place, it was down to the weather playing nice, and the vixen doing her part. With so many elements needing to work, I wasn't going to risk condensation, so used the Thermal Lens Wrap. Apart from the fox's awkward head angle, I achieved relative success.

## A FRESH PERSPECTIVE

It was almost six months later that I decided to revisit the idea of the shadow image. In the months since the original attempt, I had grown more confident with balancing ambient and artificial light, and some of the images I had taken recently also incorporated the night sky. I now had the PIR sensor and added to that, having spent the winter watching the local foxes creep around in the shadows at night whenever I was driving home, a fresh perspective to the shadow image was born and it was time to try again.

Previously, I had used my 150mm lens to fill the frame with the shadow; this time I opted for my 18–35mm at its widest focal length so that I could fit not only the wall, but the neighbouring houses beyond and the sky above within the frame.

I knew a 30-second exposure would be required to capture the night sky, and I would also need to wait until the moon was not dominating and illuminating the sky, as I didn't want to risk the potential for ambient light to either reduce the impact of the stars or cause overexposure of the wall, losing any potential shadow. I also needed a night where the sky would be clear of cloud cover so that stars could be seen. I wasn't asking for much, I'm sure you'll agree!

Waiting for my window of opportunity took a while, but eventually the moon's phase and the forecast on all three of my weather apps showed a clear spell for a few nights. It was time.

Eagerly, I set my camera up. To capture the houses beyond the wall, it had to be set quite high up on my tripod and angled back down a little, towards the floor. I knew this would create some distortion to the image, but nothing so severe that it could not be easily corrected afterwards. I clamped the flash near the bottom of the tripod at ground level, so that any shadow cast would be accurate, not disproportionate.

I placed the PIR sensor next to the flash, with a hood over the top to narrow the detection field into a concentrated area, rather than a wide detection zone, which could have resulted in the fox triggering the camera when it wasn't even in the frame.

With everything set, I once again used a crate as my pseudo fox to roughly approximate the distance she needed to be between the camera and wall. This enabled me to work out the focal length to adjust my lens to and after some trial and error, I settled at 32mm. This gave me the framing I desired within the image, while providing roughly the right distance so that the shadow would be pronounced and the fox not in frame, if everything went to plan. Once it was dark enough, I did a test exposure and everything was looking good. The sky was clear and the framing worked well, so with that I placed a handful peanuts out to encourage a visit that night, and then I went to bed.

The following morning I noted it was very cloudy when I went out to collect the camera. Looking through to see what I had captured revealed a couple of visits through the night but the shadows on-camera were terrible. Either the fox was too close to the camera, so the shadow was huge, or the fox was too close to the wall and in the frame. It didn't matter though, as it also appeared that all three of my weather apps had lied to me and the forecasted clear sky had clouded over, rendering the sky completely devoid of any interest.

Undeterred, I tried again the next night. Having left the tripod in position, all the setup work was done, so it was merely a case of putting the camera back on the ball-head and switching it on. Again, I went to bed, this time hopeful that I'd have more success than the night before.

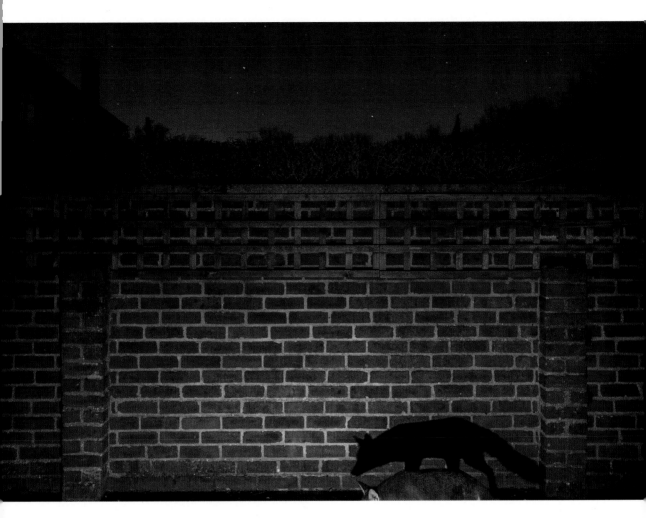

▲ Here, the fox was too close to the wall, so appeared in the bottom of the frame. There is a huge amount of chance involved with independent, mobile subjects, and this might have been the closest I would get.

## THE PERFECT COMBINATION

The next morning was a complete contrast to the previous 24 hours. The sun was shining, which instantly gave me a little more confidence for the weather that may have passed through while I was asleep, and the camera was telling me I had 12 images on the card. As I scrolled through them on the back of the camera, the first element required was certainly in place. The sky was clear and filled with stars.

The first couple of images looked similar to the night before, with some very bad shadow placement and size, and again the fox being on camera, too close to the wall. This time round I even had the badger visit, but again along the wall.

Then there it was, the next image revealed a perfect shadow, exactly what I had been after.

Sadly it was that of a neighbour's cat.

I continued scrolling. Another awkward fox shadow, and another, and another. Then, there it really was. The next image finally brought all the elements together with the vixen's shadow in the middle of the wall. In fact, the shadow was more perfect than I could have possibly hoped.

With a star-filled sky and a neighbouring light on, giving that much needed human element to the frame, the final result came together perfectly.

Shadow Walker. A glimpse into the world of the urban fox, whose day starts when ours ends.

▶ **32mm, 30 seconds, ƒ/8, ISO 1250, wired SB-28 (x1), PIR sensor.** With urban foxes often seen running between and dwelling in the shadows, I wanted to convey that story and show how they coexist with us, coming to life as we go to sleep.

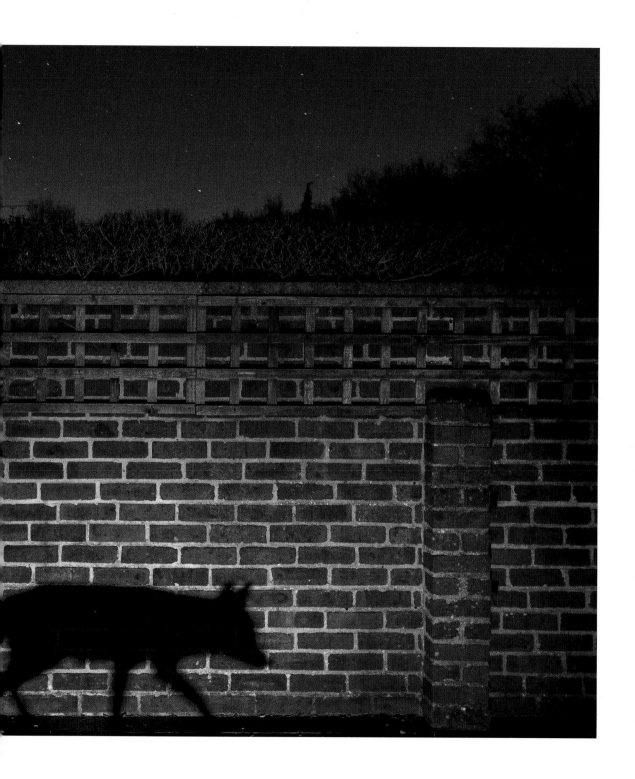

CHAPTER SEVEN

# PERSEVERANCE REWARDED

The payoff

# UNFORGETTABLE MOMENTS

**When I began this project, I did not anticipate the journey it would lead me on. I merely hoped it would be a way of building up a portfolio of new images.**

There wasn't even the idea of a book at the outset, although if you followed my social media accounts at the start, you would have seen the first two badger images appear. After that, I made a decision to not broadcast what I was doing, and simply revelled in learning a new technique that didn't revolve solely around my typical telephoto-lens-based comfort zone, and allowed me to photograph wildlife whenever I had even just an hour or two spare.

I figured I'd just get on with it and if there was something to show further down the road, I'd do so then. I didn't want to fall into the very easy trap of announcing I was working on a new project, only to end up having it fail or not really develop.

It's always important to take photos for yourself first and foremost, before doing so for any other reason. However, there is also nothing wrong with entering your images into competitions, once you have photos you're happy with. The key to choosing which image to enter lies in picking a photo that is not only visually pleasing but also has that extra ingredient that makes it stand out above the others. This could be an unusual composition or unique lighting, or one showing quirky animal behaviour. Ensure you pick only the very best images to enter, and follow the entry guidelines carefully. The last thing you want is to be disqualified because you accidentally entered an image that didn't conform to the rules.

Of course, when I started my own project, a little voice in my head spoke up occasionally suggesting it would be wonderful to have my efforts recognised in some way. Even so, I never thought that I would see so many of my images being recognised in various international competitions. Least of all did I imagine that I would be dressed up in a suit at the Natural History Museum, surrounded by some of the most creative people in the industry, eating dinner underneath a big old Diplodocus skeleton. A year after starting this project, however, that's exactly what happened.

Richard Peters, UK

## WILDLIFE PHOTOGRAPHER OF THE YEAR

Every year in May, you'll find most wildlife photographers hovering around their inboxes hoping to see a certain email arrive. The origin of that email? London's Natural History Museum, or more specifically, the office of the most respected competition in the industry, the Wildlife Photographer of the Year.

I had been fortunate enough to have one of these emails appear in my inbox once before, a couple of years earlier, to say that one of my images had been longlisted. This time round, it was a little bit different. First, the email went straight into my spam folder, and second, I did a double-take when it informed me I had won the 2015 Wildlife Photographer of the Year's Urban Category. My feelings were mixed: I was really excited but equally, because the email had appeared in my spam folder, I wasn't sure if it might just be some form of cruel joke. Happily, a quick email to the competition office confirmed that it was real.

It's rare for me to be truly speechless, but on this occasion, I was.

▲ The Wildlife Photographer of the Year awards dinner is a spectacular event, held in the main entrance hall to the London Natural History Museum. Hosted by Liz Bonnin, seeing the 2015 award winners projected on a big screen, in such beautiful surroundings, is an experience like no other. Thank you to Connor Stefanison, winner of the 'Rising Star' award, for the photo.

The hard part was sitting on the news until the award ceremony almost six months later in October. This proved to be an incredible feat of endurance, because once the shock and speechlessness passed, they were replaced with a desire to bend the ear of anyone who would listen! It was truly one of the longest summers I've ever experienced. Many photographer friends asked in the intervening months if I had ever heard back from the competition, and given that I hate to lie, I always had to answer in such a way that I wasn't saying 'No', but also wasn't giving anything away. For future reference, my favourite truthful reply that also avoided answering the question being asked was: 'I don't know anyone who has.'

As the months ticked by, anticipation built. This was especially heightened when the official awards invite dropped through my letter box during the summer. When the day finally arrived, the awards dinner and whole evening spent in the company of so many truly creative people were thoroughly enjoyable. It was with a sense of absolute privilege (and a hint of disbelief) that I collected my Wildlife Photographer of the Year Urban Category award.

While I'm not sure it will ever truly sink in, it was a fantastic feeling to be able to share not just the news, but the entire project behind the image.

The whole process of seeing the project through from that iPhone photo the year before to learning a new technique that resulted in such a wonderful outcome was truly incredible, and gave me a huge sense of satisfaction and personal achievement.

Importantly though, the project was true to the ethos of *Wildlife Photography at Home*. Striking wildlife images can be taken anywhere, and not just in exotic locations of equally exotic animals. The ability to think creatively will always be more important than what camera gear you have.

*Shadow Walker*, taken at home and captured with a relatively cheap non-pro lens, is an image that anyone could achieve. And at ISO 1000, it is within the reach of any modern DSLR, including the one that's likely to be sitting in your camera bag right now.

## GDT EUROPEAN WILDLIFE PHOTOGRAPHER OF THE YEAR

The very same week that the Wildlife Photographer of the Year email arrived, I received a call from a jury member of the GDT European Wildlife Photographer of the Year requesting some background information on the same image. Wanting to ensure it was genuine, they asked how it was taken. Of course, I sent them some failed Raw files to show the process behind capturing *Shadow Walker*. They thanked me for the additional information and that was the end of that.

A week later, while I was running a photographic workshop, my phone rang. I didn't recognise the number and declined to answer. A couple of hours later, it rang again and this time I answered. To my surprise, the president of the GDT (Germany's nature photography society) was on the line calling from Germany to inform me I had been selected as the overall winner of the 2015 competition. It's fair to say I was stunned. I've no idea how I managed to keep quiet for the rest of the workshop, but I'm pretty sure my clients would have noticed I had an extra spring in my step in the late afternoon sunshine!

Fast-forward to October and, just a week after the Wildlife Photographer of the Year awards, I found myself in Lünen, Germany, sitting in a full viewing theatre watching some truly beautiful images flash up on screen as the 2015 GDT results were revealed to the world. The two hours flew by in a flash and before I knew it, I found myself up on stage to huge applause as *Shadow Walker* was projected on the big screen.

A wonderful touch to the event was the beautiful fox-shaped trophy (shown opposite), custom made to reflect the subject of the winning image.

The annual GDT awards coincide with the society's yearly festival so the following two days were spent in the company of some truly talented photographers, being inspired by compelling imagery and talks.

It was the perfect way to end two unforgettable weeks and put an end to my first year's worth of work on my backyard project.

▲ The GDT European Wildlife Photographer of the Year awards presented me with this beautiful trophy, which reflected the subject of the winning image.

▲ *Beautiful Chaos* – Highly Commended, European
Wildlife Photographer of the Year.

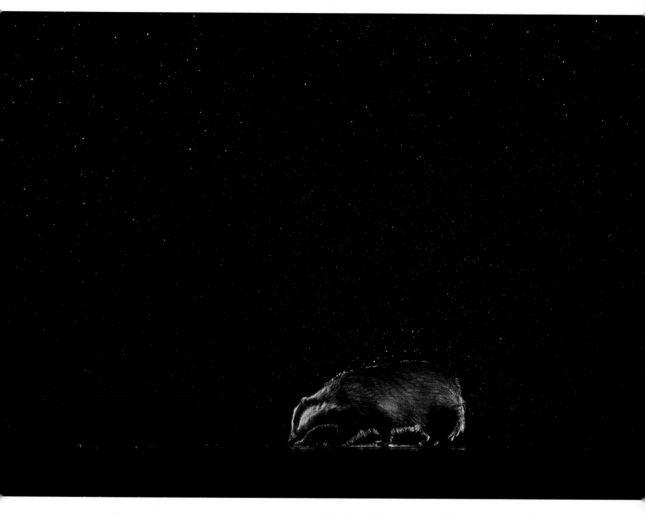

▲ *Badger Rain Shower* – Highly Commended, British Wildlife Photography Awards.

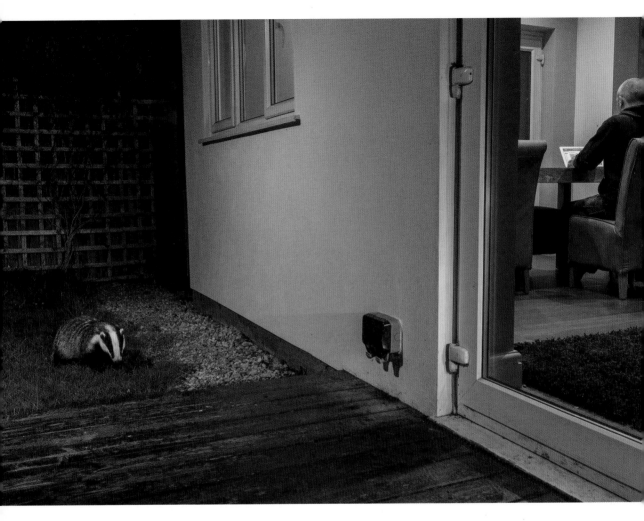

▲ *Living in Harmony* – Highly Commended, Asferico.

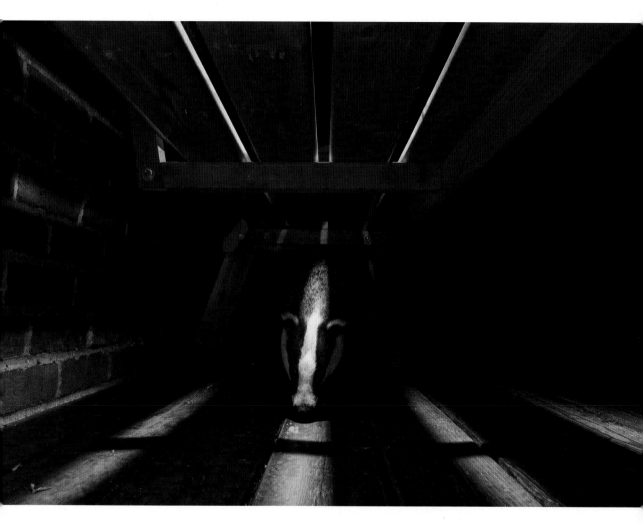

▲ *Light Shafts* – Highly Commended, International Nature Talks, International Photographer of the Year.

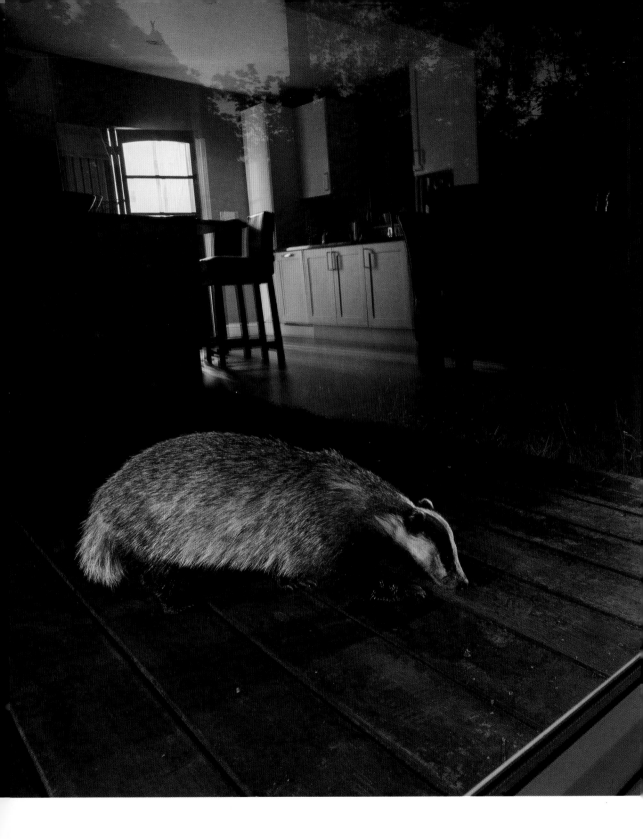

◀ *Intersecting Worlds* –
Runner-up, International
Nature Talks, International
Photographer of the Year.

# REFERENCES & RESOURCES

**Help and inspiration**

# BE INSPIRED

**The unexpected twist of finding I had badgers in my own private nature reserve has led me heavily down the path of trap cameras. It is my hope, however, that even if your garden subjects are different and trap cameras are not a direction you wish to follow, the pages and chapters that led you to this point will provide inspiration in one form or another.**

Following in my footsteps may or may not work for you, but that's the beauty of photography. Inspiration doesn't need to come in the form of imitation, so don't bog yourself down with the notion that you have to start relying heavily on techniques requiring a whole new set of gear and complications. That is not the case. Never forget that photography is all about making the most of what you have on hand. This ethos is epitomised beautifully in a quote from Elliott Erwitt:

> *To me, photography is an art of observation. It's about finding something interesting in an ordinary place... I've found it has little to do with the things you see and everything to do with the way you see them.*

Simple. Elegant. True. As is this: the more time you spend on your own backyard safari, the more your photography will be rewarded.

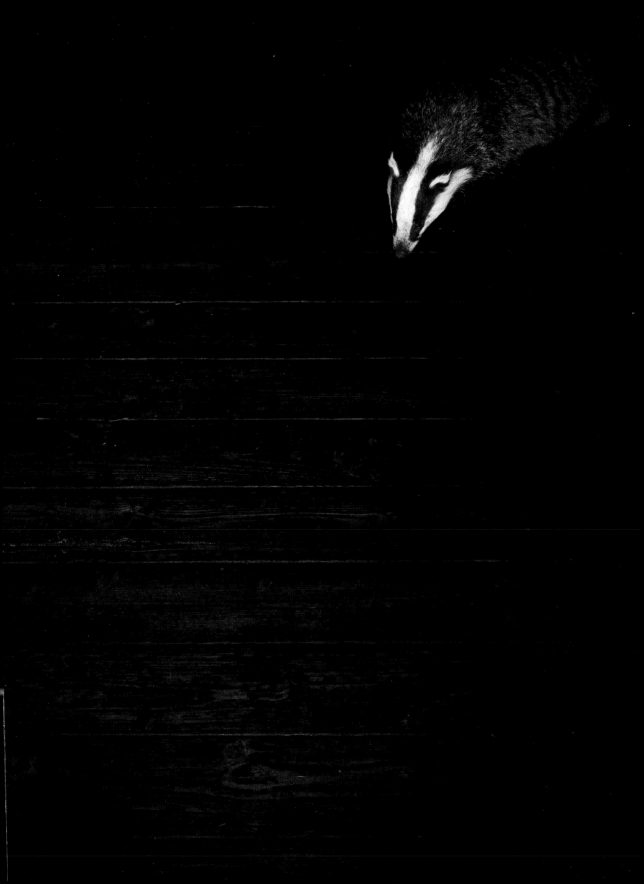

# LINKS

## EQUIPMENT

nikon.co.uk

camtraptions.com

triggertrap.com

pocketwizard.com

gitzo.co.uk

reallyrightstuff.com

lenscoat.com

wildlifewatchingsupplies.co.uk

eneloop.eu

## LIGHTING ADVICE

Strobist.co.uk

## WILDLIFE TRUSTS

badger.org

WildlifeTrusts.org

## COMPETITIONS

Wildlife Photographer of the Year

European Wildlife Photographer of the Year

Asferico

British Wildlife Photography Awards

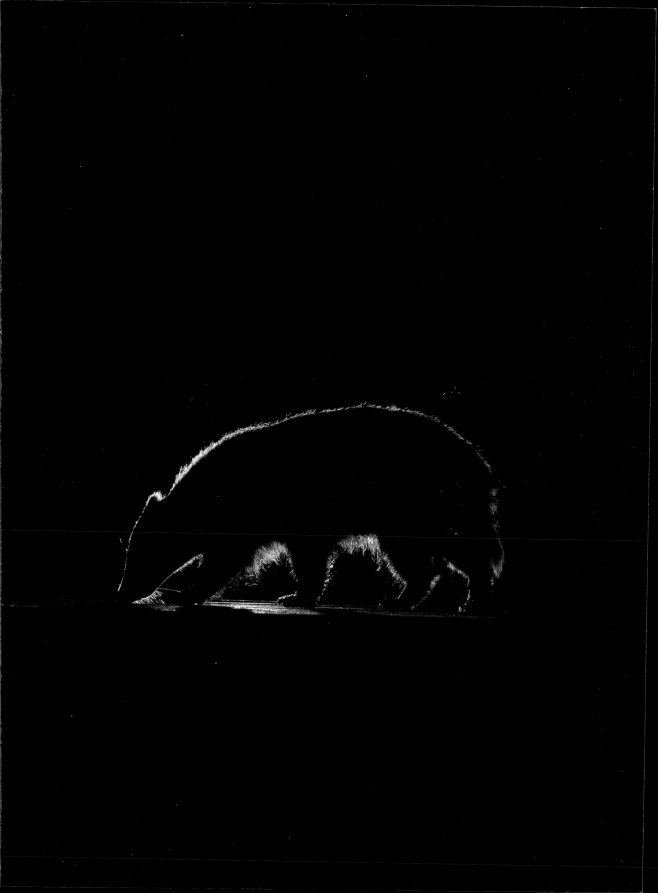

INDEX

# ACKNOWLEDGEMENTS

There are times when having the support of loved ones is more important than any technical skill or piece of camera equipment. This was most certainly the case with my 'Back Garden Safari' – the project that went on to become *Wildlife Photography at Home*.

Wildlife photography is not always the most sociable of professions, even without the need to travel. To that end, this book is dedicated to family, friends and especially my wife, who all remained exceptionally supportive when on the receiving end of my countless late nights, my removal of lightbulbs around the house to replace with flashguns, turning the kitchen table into a workshop, lack of attendance at social events and running into the kitchen to look out the window every few minutes, and who generally put up with all the mildly obsessive behaviours involved with getting the shots just right.

This adventure simply wouldn't have become all that it did, without that support. Thank you.